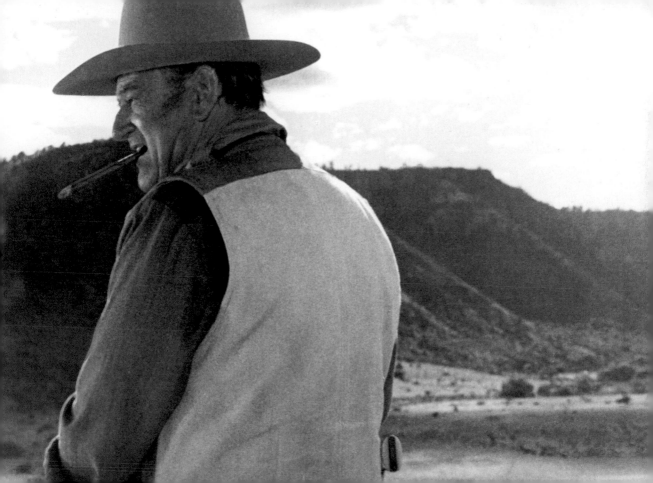

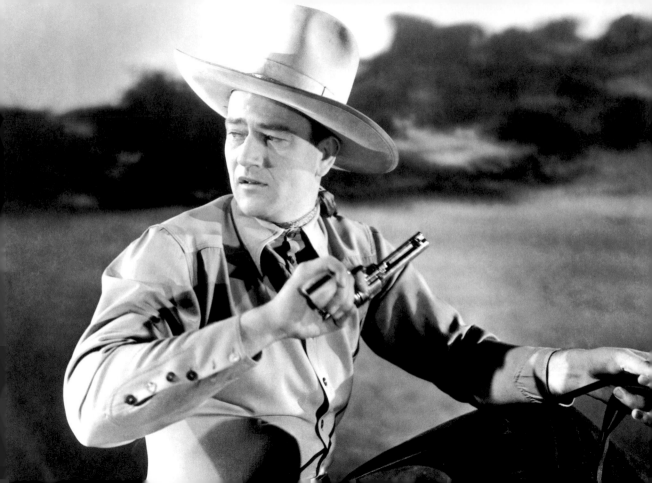

John Wayne

A PHOTOGRAPHIC CELEBRATION

Skyhorse Publishing books may be purchased in bulk at special discounts for sales promotion, corporate gifts, fund-raising, or educational purposes. Special editions can also be created to specifications. For details, contact the Special Sales Department, Skyhorse Publishing, 307 West 36th Street, 11th Floor, New York, NY 10018 or info@skyhorsepublishing.com.

Skyhorse® and Skyhorse Publishing® are registered trademarks of Skyhorse Publishing, Inc.®, a Delaware corporation.

Visit our website at www.skyhorsepublishing.com.

10 9 8 7 6 5 4 3 2

Library of Congress Cataloging-in-Publication Data available on file.

Print ISBN: 978-1-63450-775-2
Ebook ISBN: 978-1-62914-265-4

Printed in China

John Wayne

A PHOTOGRAPHIC CELEBRATION

edited by Marc Mompoint
introduction by Brian Downes

Skyhorse Publishing

Introduction

It's an honor to have been asked to write a few lines about *John Wayne: A Photographic Celebration*. Even for old John Wayne hands like me, this collection of our hero's most memorable lines placed artfully among so many rarely seen photos reminds us all of Wayne's enduring appeal.

Among my most life-defining experiences was a springtime day in 1977, when I had been invited to spend a day with the actor at his home in Newport Beach, California. My newspaper days with the *Chicago Tribune* were just beginning, and while Mr. Wayne seemed as robust as ever, his long bout with a series of illnesses that would finally claim him was just months away.

As a larger-than-life cultural figure, John Wayne did not disappoint. He was as intelligent as he was boisterous and as reflective as he was funny. But he was also gentle, gracious, and caring.

Lessons learned from John Wayne onscreen, in print, and from personal observation: we should determine never to whine, always treat everyone with respect and dignity, and to personally respond to letters and phone calls promptly. John Wayne taught us that a man who is not generous is no man at all, that heroes are flawed, that we must love our families with all our heart, and we should always wave our flag and hold our country dear and honor those who sacrificed all to make the American dream possible.

We also learned patience and perseverance, qualities an impatient John Wayne embraced as well.

Duke, we hope you are half as proud of us as we are of you.

Brian Downes, Director
John Wayne Birthplace Museum
Winterset, Iowa

"I'm the stuff men are made of."
—JOHN WAYNE

"Just call me Duke."
—JOHN WAYNE

On May 26, 1907, Wayne was born in Winterset, Iowa, to Clyde Morrison, a pharmacist of Scottish descent, and Mary Brown, a homemaker of Irish descent.

In honor of his grandfather, Marion Mitchell Morrison, Wayne was named Marion Robert Morrison. When his parents decided to call their next son Robert, they changed Wayne's middle name to Michael, not Mitchell, as many film historians state.

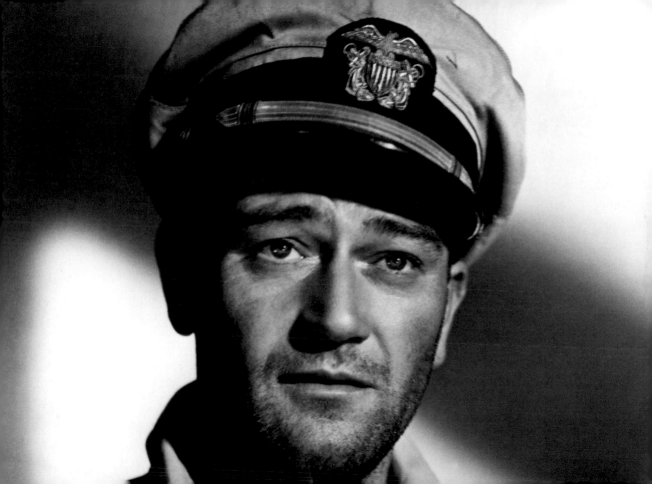

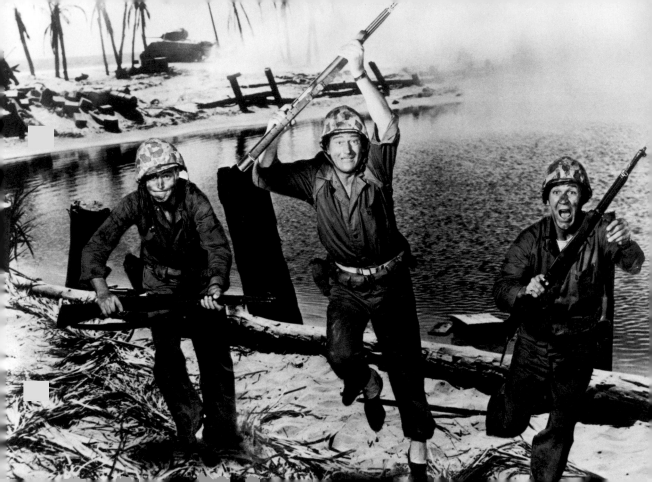

"I didn't get famous doing drawing room comedies."
—JOHN WAYNE

"A man's character and personality is made up by the incidents in his life. Mine has been made up of one thing in reel life, and possibly every dramatic experience that a human being could have in real life. Somewhere in between lies John Wayne. I seldom lie."
—JOHN WAYNE

At seven years old, the Morrisons left Iowa to take over Clyde's
father's estate in Antelope Valley, a drab region north of L.A.
"I hated living in Antelope Valley," Wayne recollected.
"There were so many rattlesnakes, I had nightmares about them.
We were living in little more than a rambling
shack with no electricity."

"I don't want to ever appear in a film that would embarrass a viewer. A man can take his wife, mother, and daughter to one of my movies and never be ashamed or embarrassed for going."
—JOHN WAYNE

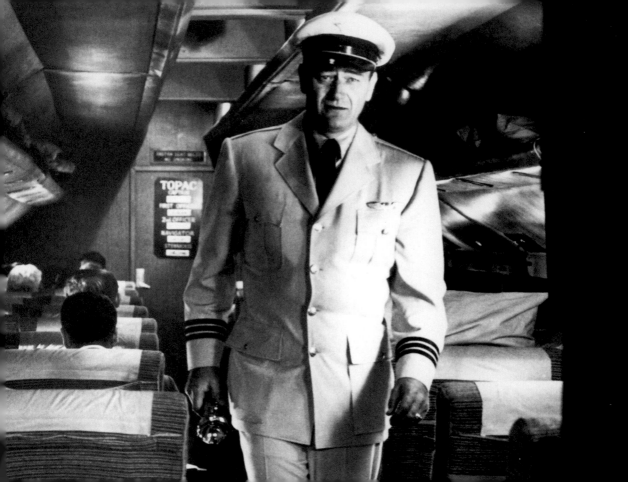

The airport in Orange County, California, was renamed the John Wayne Airport shortly after his death.

"You can't whine and bellyache because somebody else got a good break and you didn't."
—John Wayne

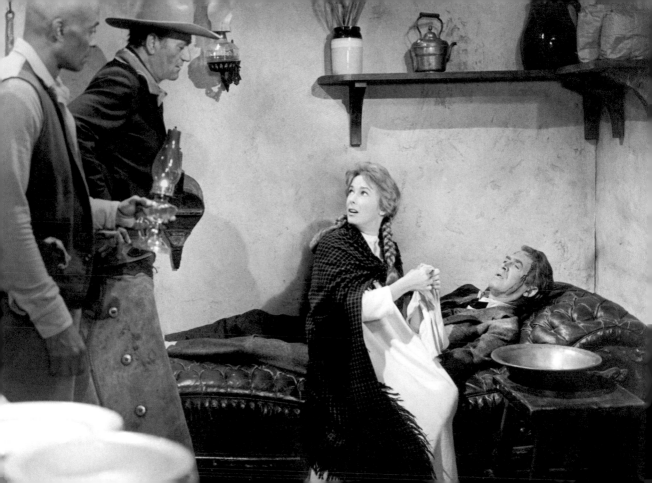

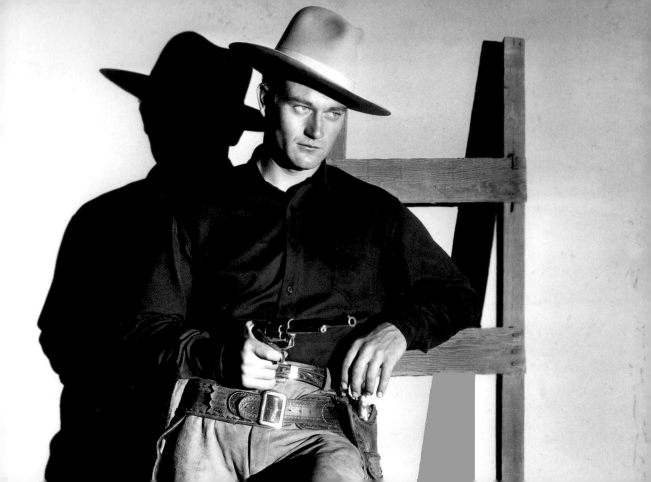

"He portrays John Wayne, a rugged American guy. He's not one of those method actors, like they send out here from drama schools in New York. He's real, perfectly natural."
—JOHN FORD, DIRECTOR

"My buildup was done through constant exposure. By the time
I went overseas to visit our boys during the Second
World War, they had already seen my movies when they were
back home. Now their kids are grown up and their kids
are seeing my movies. I'm part of the family."
—JOHN WAYNE

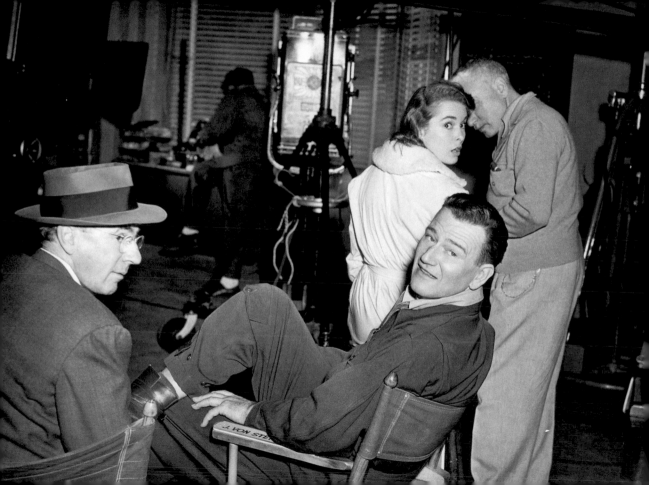

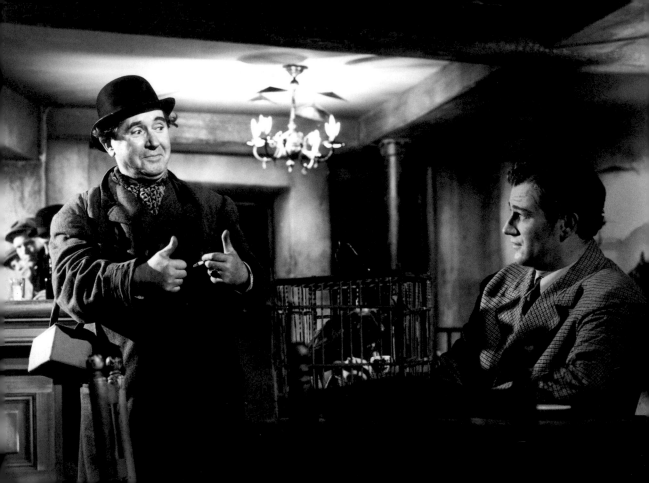

After the move from Iowa to California, it became standard fare
for young Marion Morrison to have to defend his
Midwestern accent and curious name to bullying classmates.
He would often return home coated in blood and
dirt from the school day's scuffle.

"I've always followed my father's advice: he told me, first to always keep my word and, second, to never insult anybody unintentionally. If I insult you, you can be goddamn sure I intend to. And, third, he told me not to go around looking for trouble."
—JOHN WAYNE

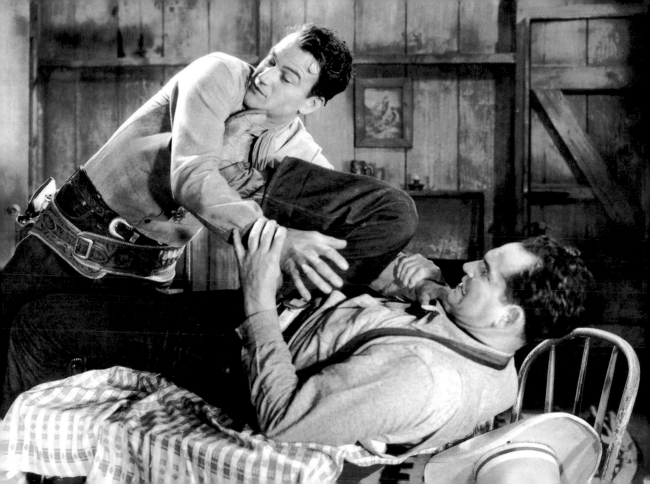

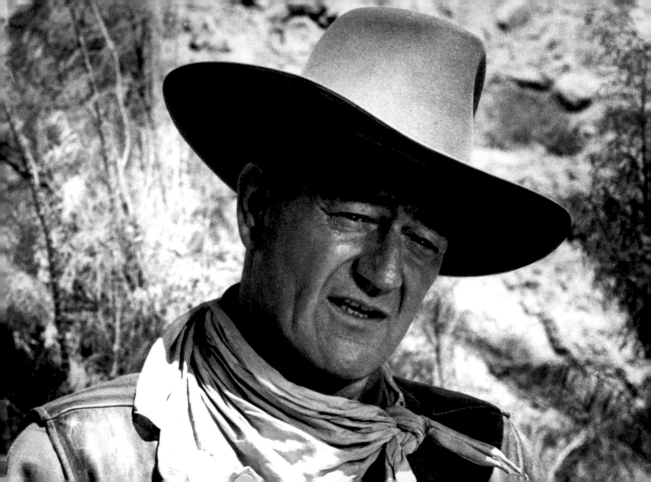

"A man's got to have a code, a creed to live by, no matter what"
—JOHN WAYNE

What the studio says goes. After casting him in *The Big Trail* (1930), they decided that Marion Morrison needed a new name, and quickly. Director Raoul Walsh came up with "John Wayne."

"John Wayne was bigger than life. In an age of few heroes, he was the genuine article. But he was more than a hero.
He was a symbol of many of the qualities that made America great. The ruggedness, the tough independence, the sense of personal conviction and courage—on and off the screen—reflected the best of our national character."
—President Jimmy Carter

Wayne inherited "The Duke" nickname from his childhood dog.
He and the Airedale terrier had been inseparable.

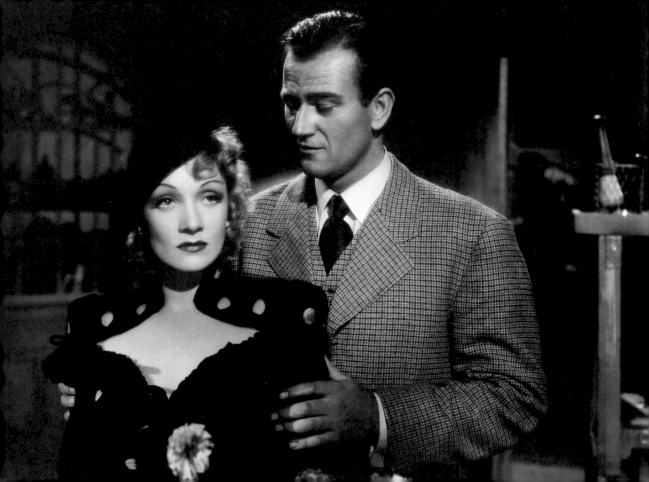

"I can tell you that the reason that he had been so successful, and became even more successful, was because he was the hardest working actor that I ever knew. He worked damn hard to prove himself."
—JOHN FORD

"I'm always the straight guy who heaves the pack up on his back and shouts 'Follow me!' Everybody else in the picture gets to have funny scenes, clever lines, but I'm the hero, so I just stand there."
—JOHN WAYNE

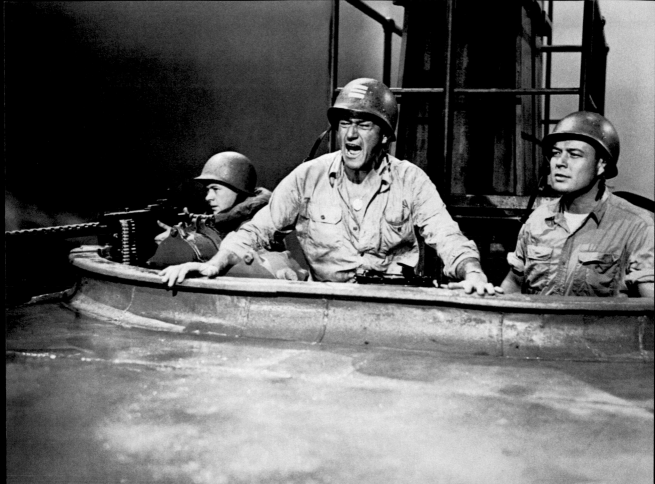

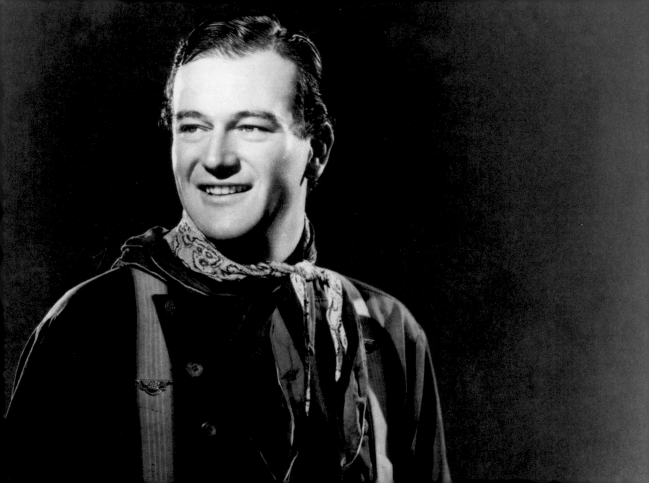

Wayne claims a bodysurfing injury put an early end to his
football career. With no athletic scholarship and no
plan B, he was forced to drop out of school and start work
at a film studio prop department.

"I'm an old-fashioned, honest-to-goodness, flag-waving patriot."
—JOHN WAYNE

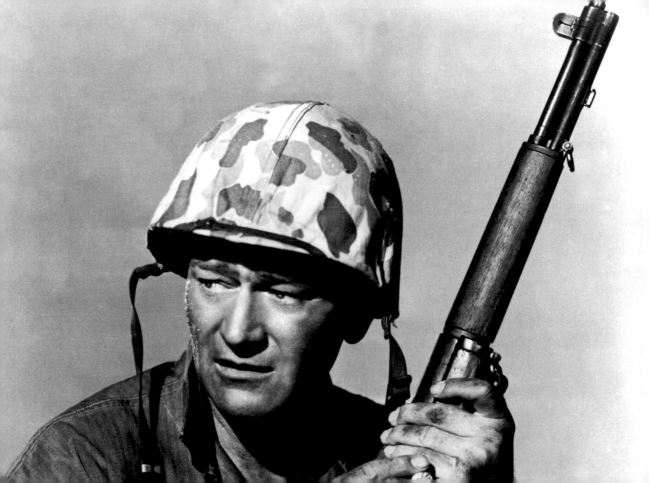

Wayne's role as Ring Kid in *Stagecoach* (1939) truly made him a star. In this movie, directed by John Ford, Wayne shared top billing with costar Claire Trevor. By this time, he already had roles in more than 70 action and Western B movies.

"The film had an ensemble cast and of all us actors who rode that Stagecoach, Wayne had the least lines of dialogue. And yet he dominated the film back in 1939, and he still dominates it today."
—JOHN CARRADINE

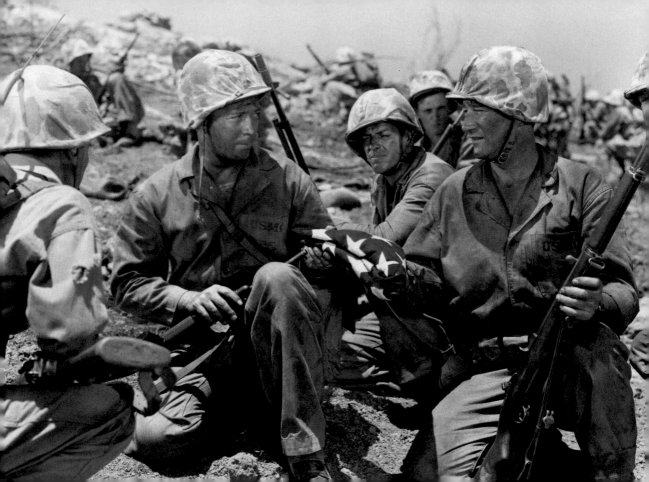

"If you've got them by the balls their hearts
and minds will follow."
—JOHN WAYNE

"One look that works is better than twenty lines of dialogue . . .
Let those actors who picked their noses get all the dialogue, just
give me the close-up of reaction."
—JOHN WAYNE

There is a scene in *Donovan's Reef* (1963) where John Wayne miscalculates a blow from Lee Marvin. He ended up crashing through a table, and director John Ford decided to keep the take for the final copy of the film.

"He was the hero. With him, right always prevailed. There's an American optimism with John Wayne. People looked up to him. He was an imposing figure at 6 feet, 4 inches tall. And he had that classic Hollywood mystique."
—TIM O'DEA, PUBLICIST

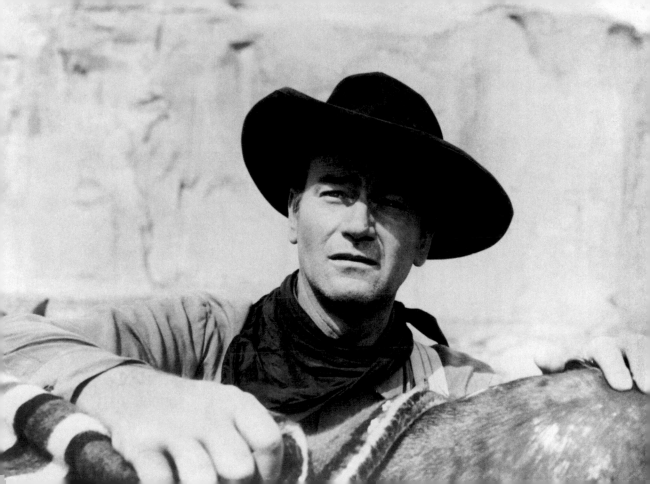

A 23 year-old Wayne plays a bit part in the musical *Cheer Up and Smile* (1930), his last minor role before becoming a star.

"He chose roles and films that personified characters that he believed in. When we see him on film, and when we see him interviewed, John Wayne is what we think of when we think about, historically, the more positive aspects of our country. He reflects an age and time when we were more optimistic and more passionate about the values that our country stood for."
—GREGG SCHWENK, EXECUTIVE DIRECTOR OF THE NEWPORT BEACH FILM FESTIVAL

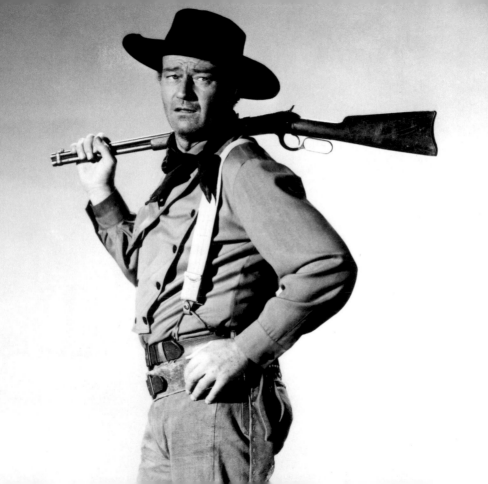

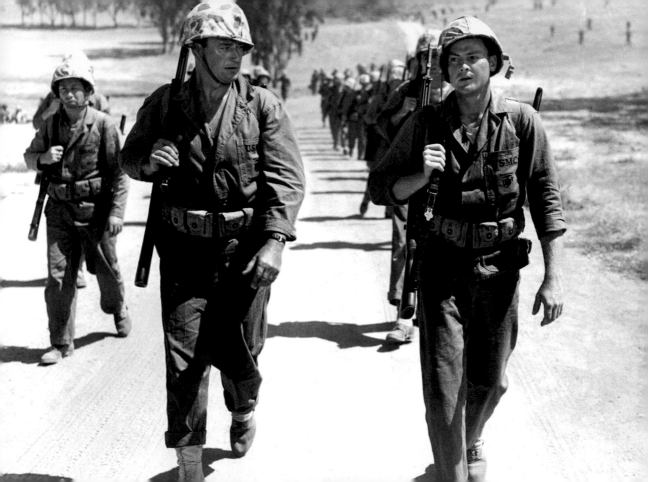

"A lot of guys make mistakes, I guess, but every one we make, a whole stack of chips goes with it. We make a mistake, and some guy don't walk away—forevermore, he don't walk away."
—JOHN WAYNE IN *SANDS OF IWO JIMA* (1949)

He appeared in nearly 250 movies, many of epic proportions.
To this day, the Duke still holds the record for the
most leading roles of any actor.

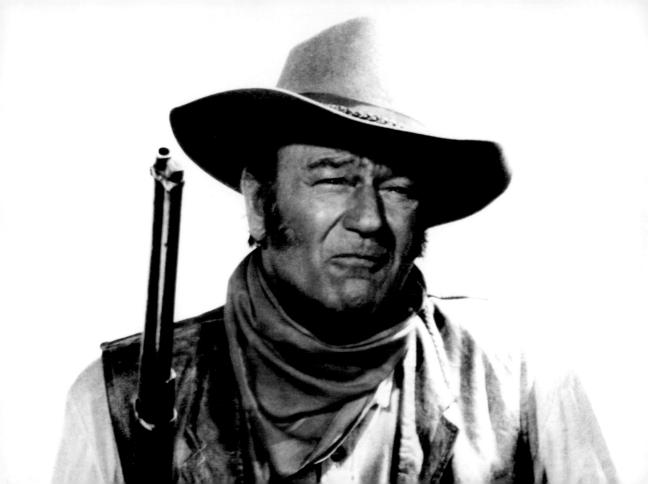

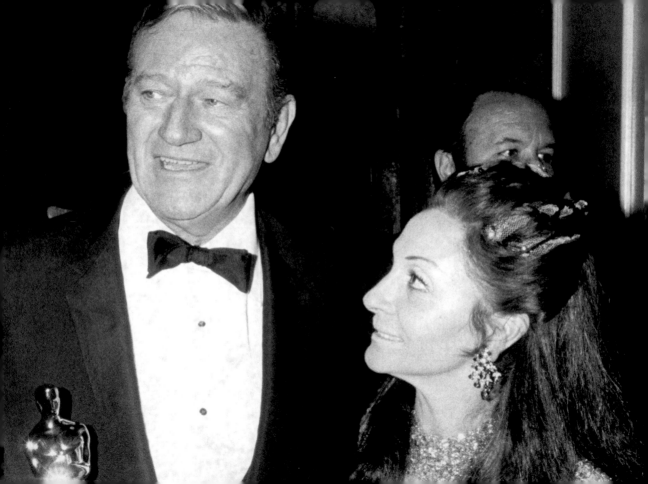

"You can't eat awards. Nor, more to the point, drink 'em."
—JOHN WAYNE

"Never say sorry—it's a sign of weakness."
—JOHN WAYNE

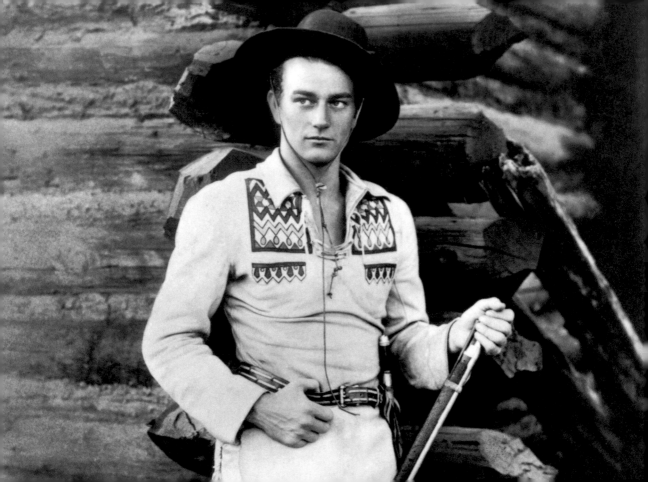

"When I started, I knew I was no actor and I went to work on the
Wayne thing. It was as deliberate a projection as you'll
ever see. I figured I needed a gimmick so I dreamed up the drawl,
the squint, and a way of moving meant to suggest that
I wasn't looking for trouble but would just as soon
throw a bottle at your head as not."
—JOHN WAYNE

Wayne was starkly anticommunist in the McCarthy era, and he had a hand in the formation of the Motion Picture Alliance for the Preservation of America Ideals. In 1947, he was elected president of the organization.

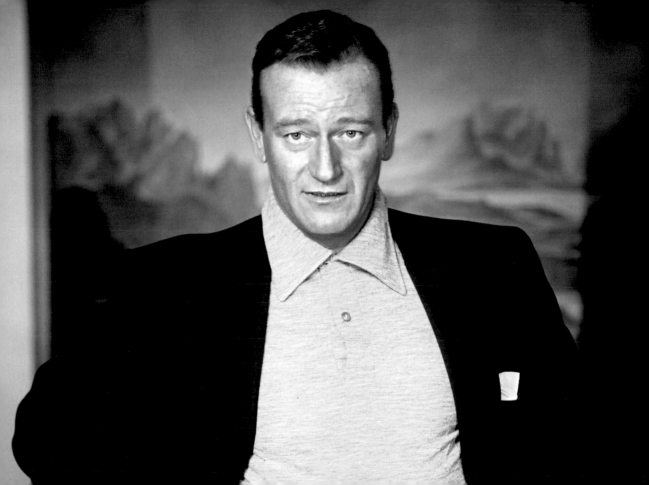

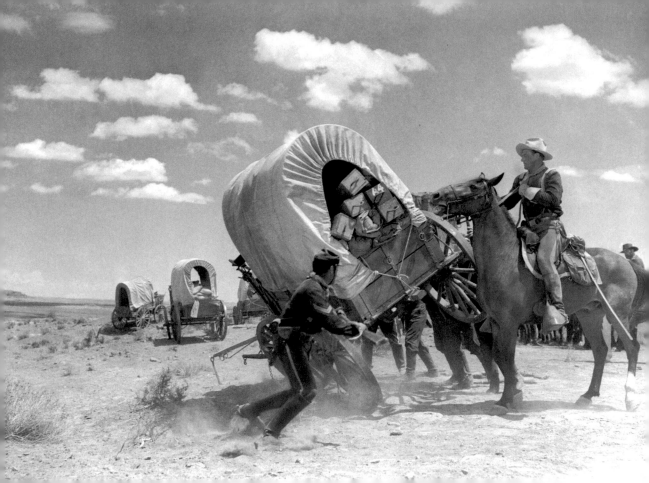

"Westerns are closer to art than
anything else in the
motion picture business."
—JOHN WAYNE

Despite receiving generally favorable reviews on its release, *The Shootist* (1976) proved to be one of John Wayne's least successful movies.

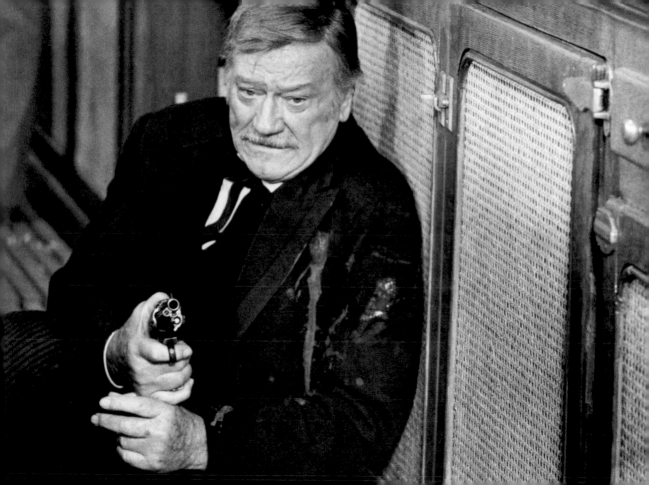

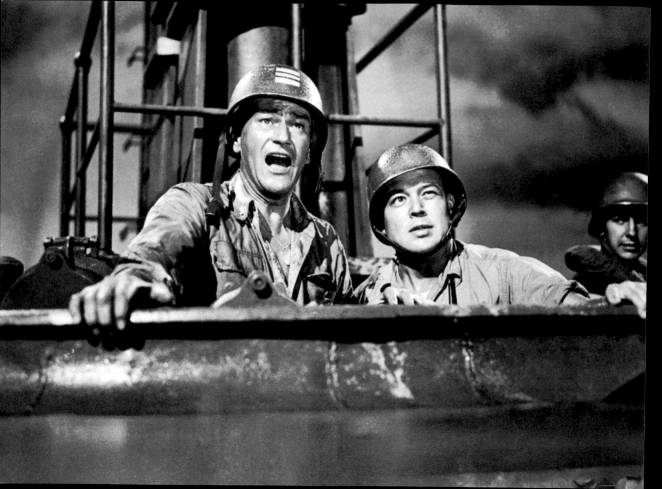

"When you come slam bang up against trouble, it never looks half as bad if you face up to it."
—JOHN WAYNE

"When the road looks rough ahead, remember the Man upstairs and the word *Hope*. Hang on to both and tough it out."
—JOHN WAYNE

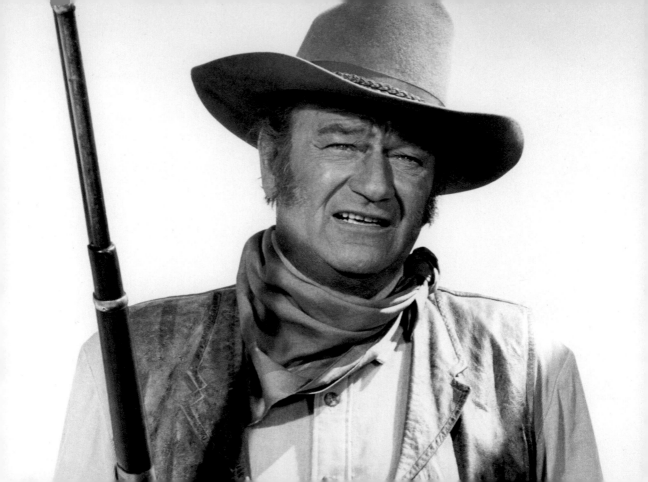

On the set of *The Undefeated* (1969), Wayne not only fractured three ribs falling from a horse, but later also tore his shoulder ligament. Director Andrew V. McLaglen filmed Wayne solely from angles that hid the fact that he could only use one of his arms.

Different directors filmed different segments of *How The West Was Won* (1962). Wayne was originally cast to play a role in the segment directed by Henry Hathaway, but John Ford demanded that he appear in his own Civil War sequence.

"Wayne was a very, very good actor,
in the most highbrow sense of the word."
—KATHARINE HEPBURN

"Well there are some things a man just can't run away from."
—JOHN WAYNE IN *STAGECOACH*

The real Frank Wead, played by Wayne, grew noticeably balder as he got older. *The Wings of Eagles* is the only film in which John Wayne appears without his toupee.

All three of Wayne's wives were of Latino descent.

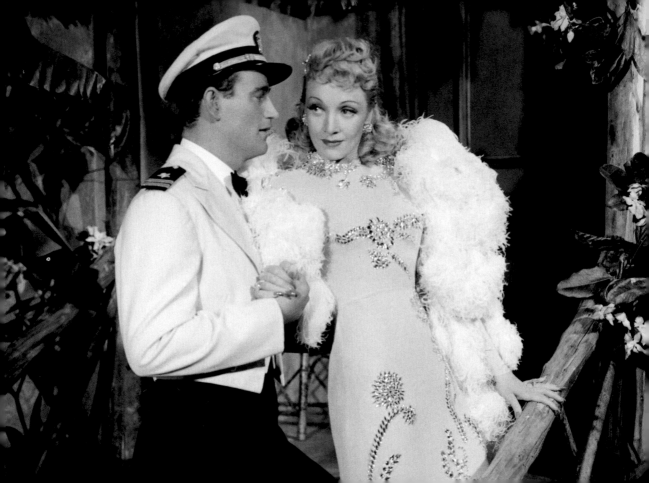

"Duke was caught up in this incredible love affair with Marlene, who really beguiled him with her vast experience as a lover."
—PAUL FIX, ACTOR

"Wayne had several high-profile affairs. Duke's affair with Dietrich was the worst-kept secret in Hollywood. They would appear in public together at Hollywood events."
—HENRY HATHAWAY, ACTOR

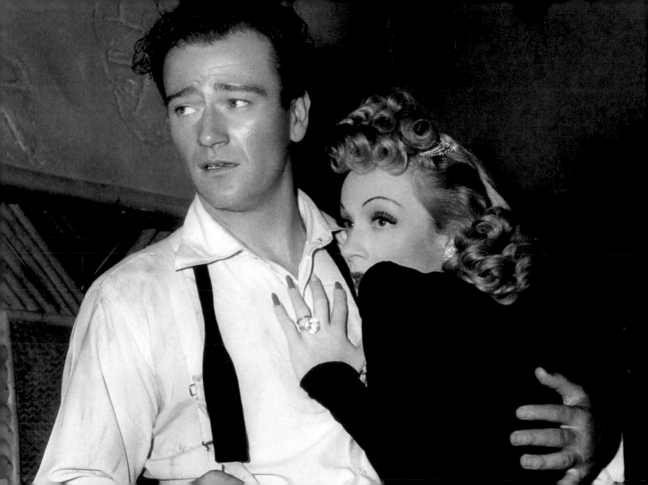

John Wayne enjoyed working with Lauren Bacall in
their first film together, *Blood Alley*
(1955), so much that he handpicked her as his
leading lady for *The Shootist*.

"Some people thought we must have been
having an affair, but that wasn't so.
Duke liked dark, Latin types,
and I was blonde. Not his type at all."
—Claire Trevor

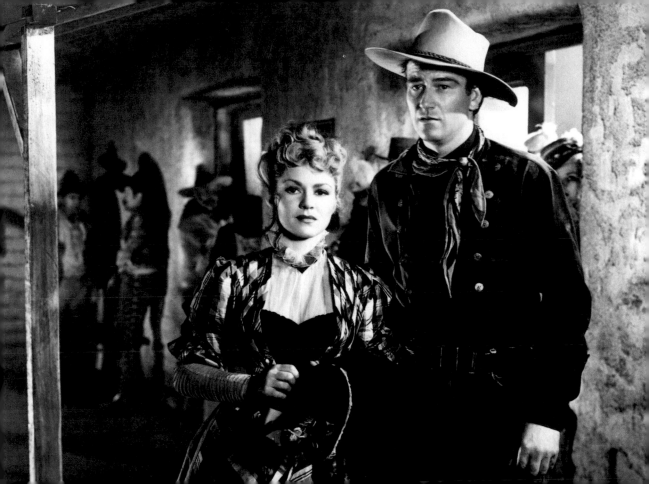

The character of Detective Lieutenant James Brannigan
in the film *Brannigan* (1975) was written to be in his late 50s,
but John Wayne took on the role at 67.

"Wayne is, of course, marvelously indestructible, and he has become an almost perfect father figure."
—Vincent Canby, *New York Times* film critic

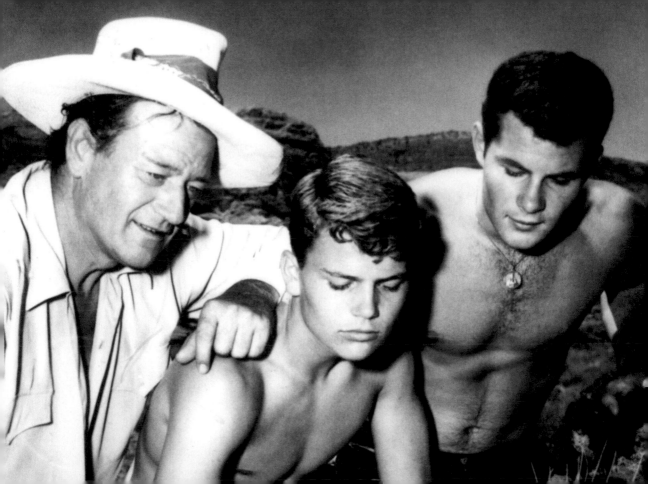

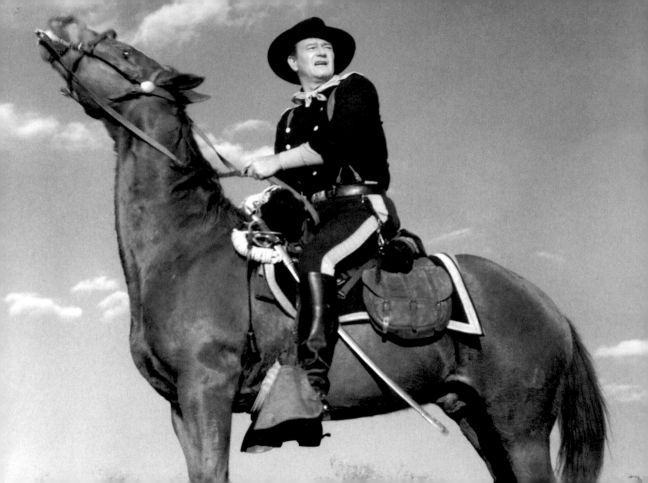

"Wayne has never underestimated one of the greatest axioms of a good Western—a good silent man with a horse is better than two hours of talk."
—DAVID SUTTON, SATURDAY EVENING POST

In exchange for a seat at a football game, Tom Mix pulled strings to get Wayne a summer job as a prop man. It was on that set that Wayne developed an immediate friendship with director John Ford, most notably famous for his Oscar-winning adaptation of *The Grapes of Wrath* (1940).

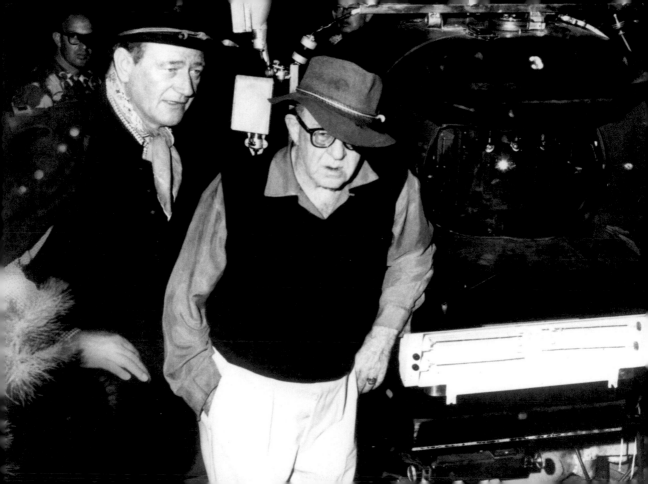

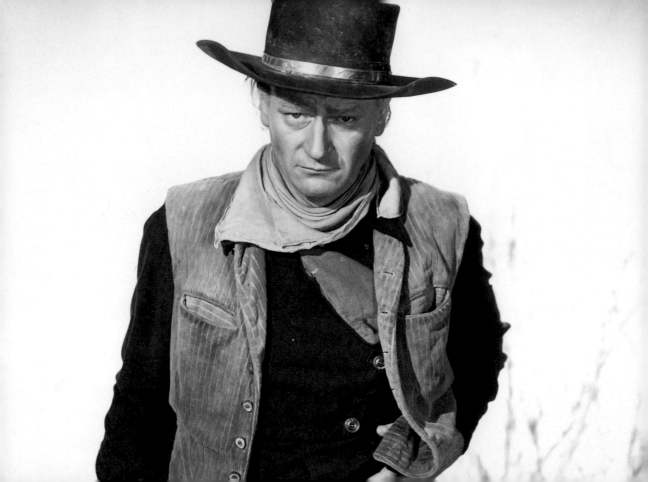

"We called him Duke and he was every bit the giant off the screen
that he was on. Everything about him—his stature,
his style, his convictions—conveyed enduring strength, and
no one who observed his struggle in those
final days could doubt that strength was real."
—RONALD REAGAN

Sharing a title with one of Wayne's pictures, a song
called "She Wore a Yellow Ribbon" is the
official anthem of the United States Cavalry.

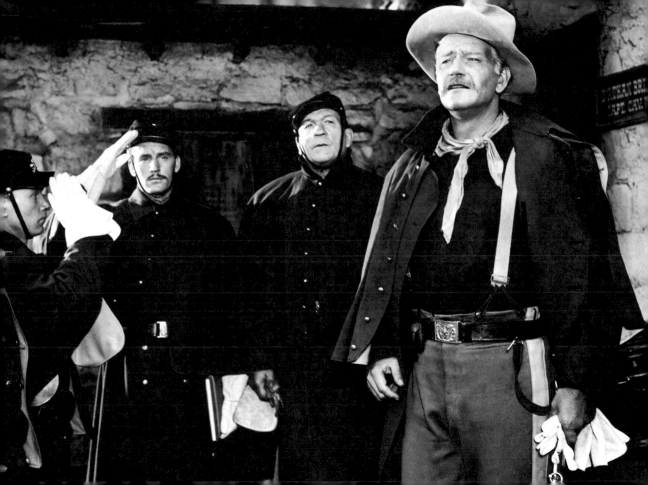

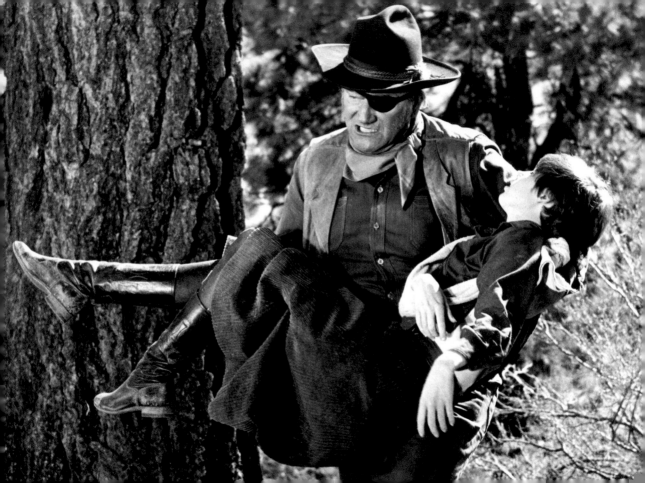

Marguerite Roberts, the once blacklisted author of *True Grit* (1969), was a member of the American Communist Party in 1951. Wayne was fully aware of this before reading the script and ignored the grumbles of those who questioned if he should be working with her. In 1969, the film won Wayne his first Oscar for Best Actor.

"Those who like me already know me, and those
who don't like me wouldn't
want to read about me anyway."
—JOHN WAYNE

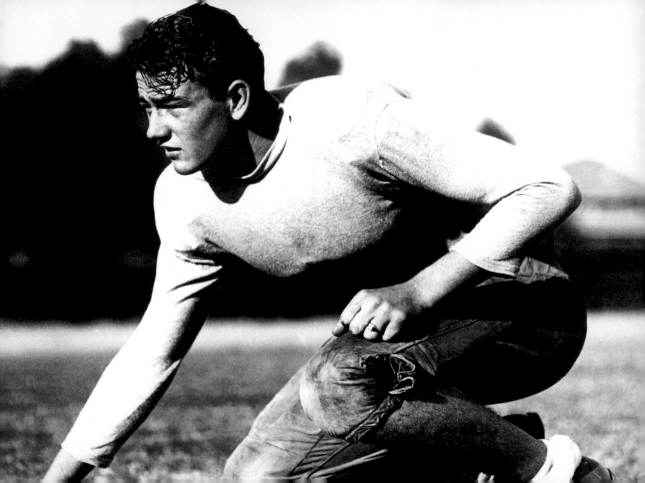

After high school, Wayne applied to the U.S. Naval Academy but was not accepted. He instead attended the University of Southern California, majoring in pre-law.

"There's a lot of yella bastards in the country who would like to call patriotism old-fashioned. With all that leftist activity, I was quite obviously on the other side."
—JOHN WAYNE

Early in his career, Wayne had a number of films in the character
of a "singing cowboy," though he wasn't known
for his singing chops. A singer located off camera provided
the actual voice used on film.

"This kind of war, you've gotta believe in what you're fighting for."
—JOHN WAYNE IN *BACK TO BATAAN* (1945)

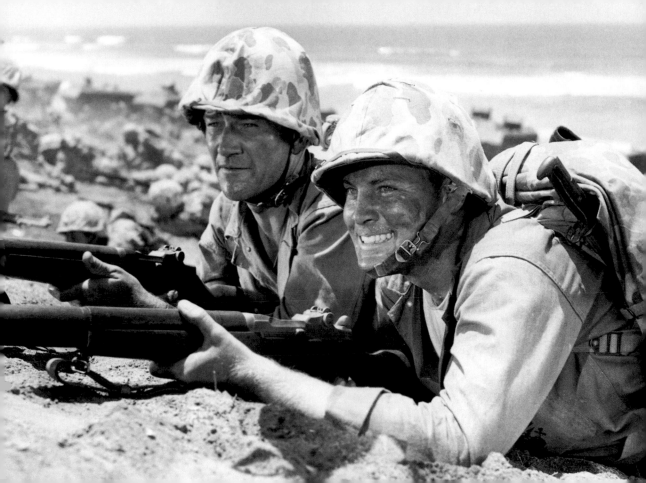

"John Wayne is loved the world over as a man who represents independence, the love of freedom, and the hearty strength of character that made our country great. For audiences at home, John Wayne, through his films, remains an authentic folk hero. In this era of shifting moral values and cynicism, he has made a contribution of inestimable value to American culture . . ."
—GREGORY PECK, COSTAR OF *HOW THE WEST WAS WON* (1962)

"The way the screenplay reads, this is a cowboy picture, and that's how I am going to play Genghis Khan. I see him as a gunfighter."
—JOHN WAYNE ON PLAYING GENGHIS KHAN IN *THE CONQUEROR* (1956)

"The perfect movie star is John Wayne . . . He brings so
much authority to a role he can pronounce
literally any line in a script and get away with it."
—KIRK DOUGLAS

Beginning in early adulthood, Wayne was an acknowledged chain-smoker. It's reported that he daily went through five or more packs of Camels, his cigarette of choice.

"The West—the very words go straight to that place of the heart where Americans feel the spirit of pride in their Western heritage—the triumph of personal courage over any obstacle, whether nature or man."
—JOHN WAYNE

Rock Hudson, Wayne's costar in *The Undefeated*, insisted that he shared a firm friendship with John Wayne. There were speculations as to the truth of this when director Andrew V. McLaglen advised Hudson not to bring his boyfriend, Jack Coates, to the set in Mexico out of respect for Wayne's conservative views.

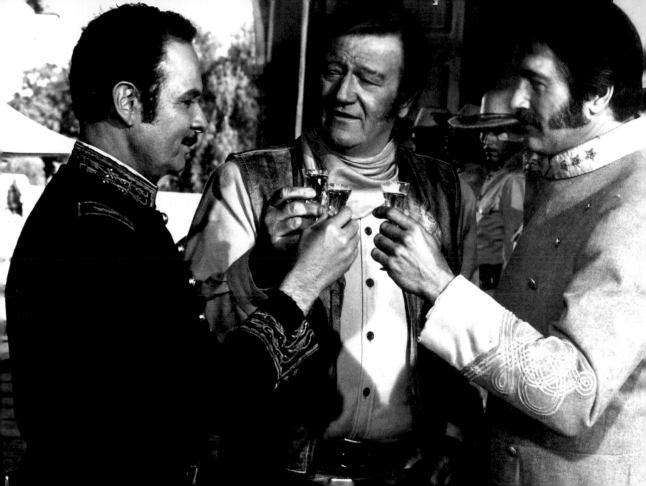

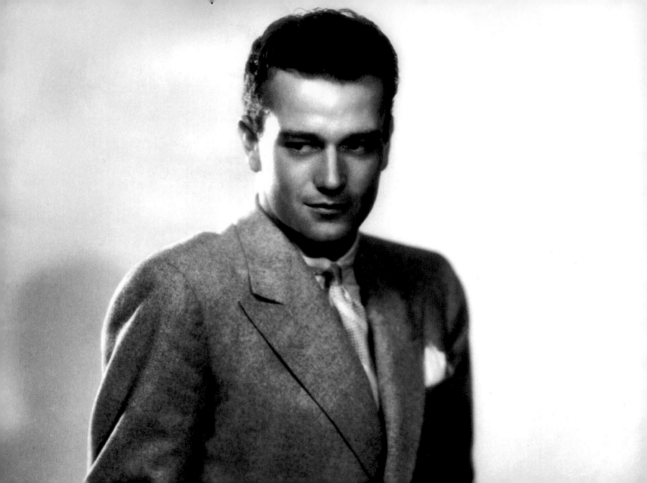

"Unfortunately people confuse gracefulness with softness.
John Wayne is a graceful man and so are some of
the great ballplayers . . . but, of course,
they don't run the risk of being called sissies."
—Gene Kelly

Katharine Hepburn was the original pick to play opposite Wayne in *Hondo* but passed on the film thanks to firm differences with his conservative views and affiliations. Funny how things work out. Twenty years later, Hepburn and Wayne eventually shared a set in *Rooster Cogburn* (1975).

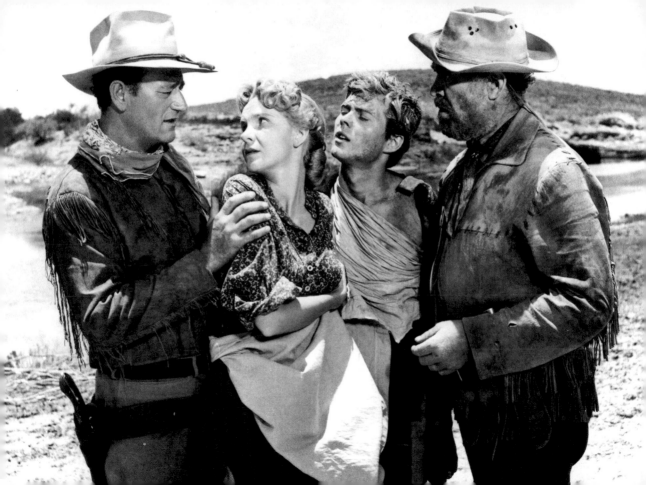

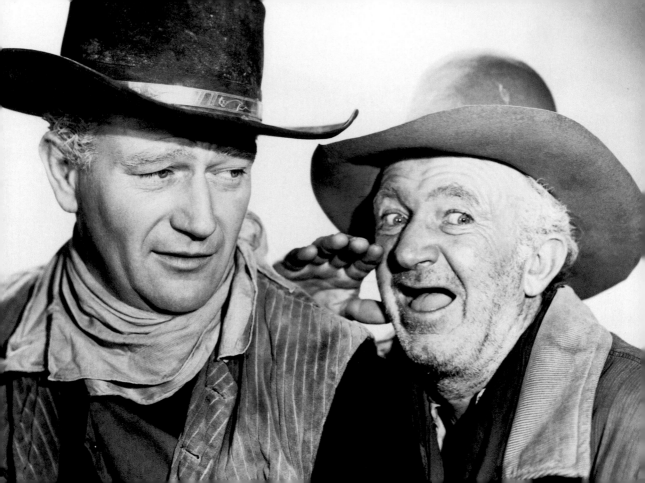

"Very few of the so-called liberals are open-minded
They shout you down and won't
let you speak if you disagree with them."
—JOHN WAYNE

"When people you work with do their job to make
things right and still have time to smile
and get along with others, I want them around."
—JOHN WAYNE

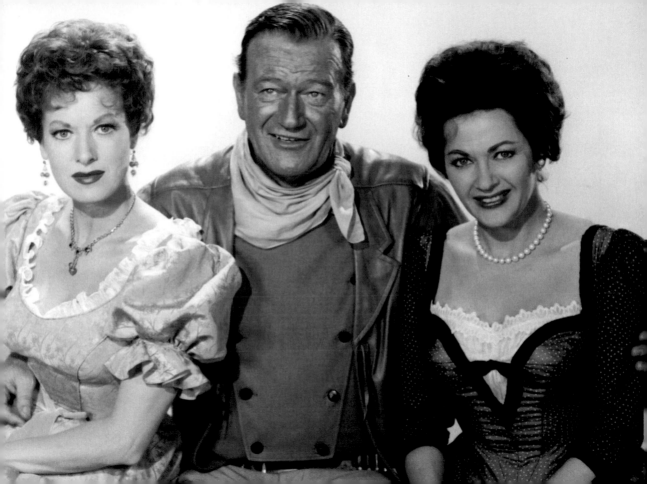

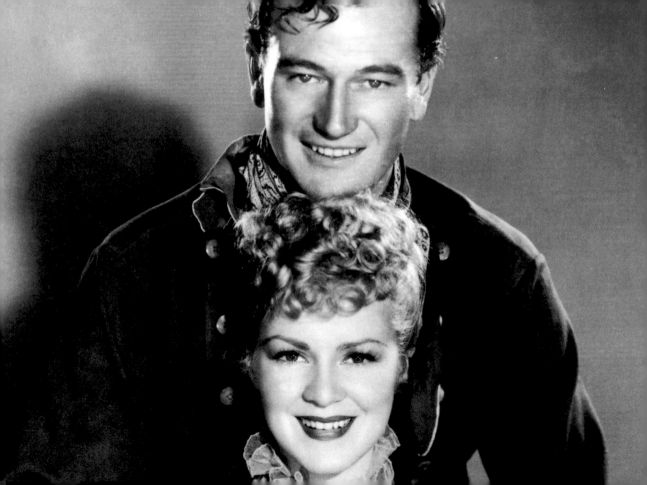

"I think Duke and I had a chemistry that really came across on film. We liked each other in real life, and became great friends."
—CLAIRE TREVOR

Wayne was a member of the National Rifle
Association (NRA). He kept a collection of firearms, and
would often keep an arsenal and ammunition
on set for hunting and trapshooting.

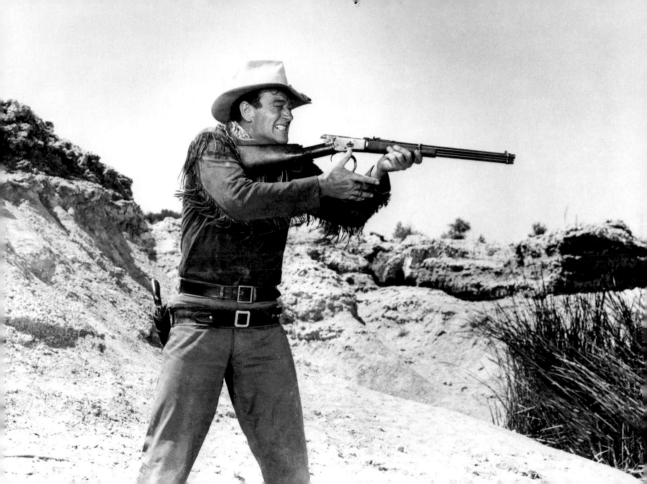

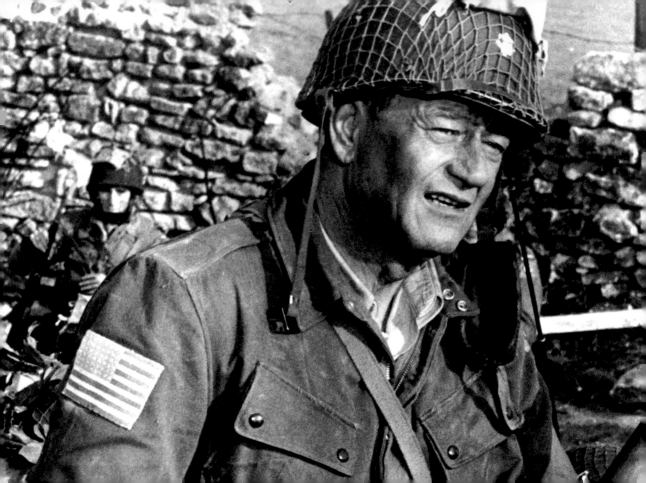

"I licked the Big C. I know the man upstairs will pull the plug when he wants to, but I don't want to end my life being sick, I want to go out on two feet—in action."
—JOHN WAYNE, ON BEATING CANCER

August 1973 marked the death of director John Ford. Wayne said it was like losing his father all over again.

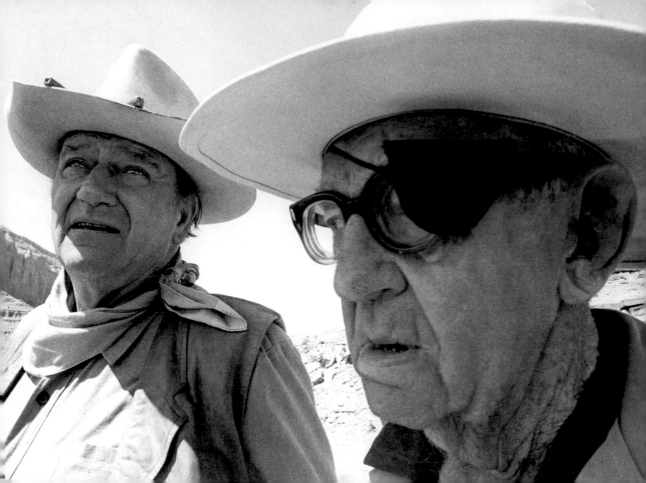

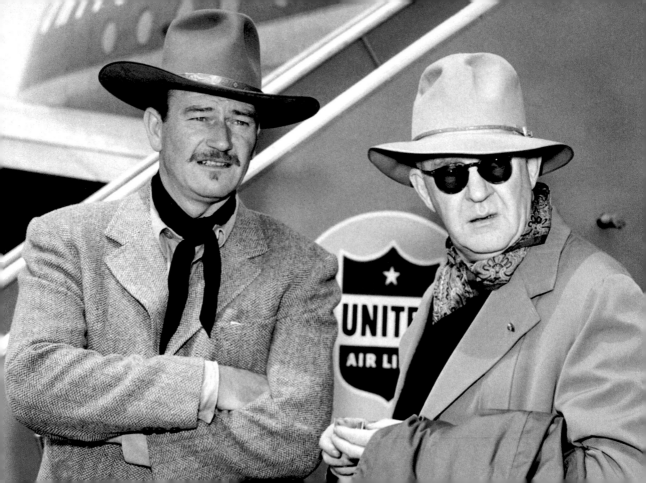

"There was Duke Wayne playing cards every night—and Duke was a great cardplayer—but he had to lose so as to not upset the old man. Duke just did anything to keep Ford happy."
—BEN JOHNSON

The Duke suffered through surgery to remove his left lung after being diagnosed with lung cancer in 1964. Though doctors declared that he had beaten the disease, five years later he began smoking cigars and chewing tobacco.

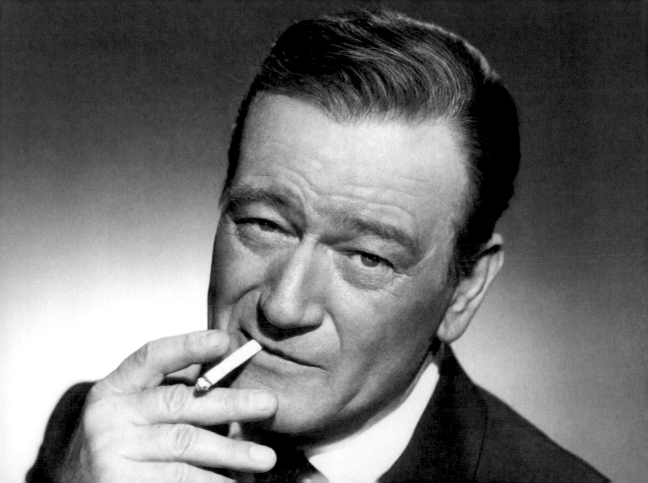

"My main object in making a motion picture is entertainment. If at the same time I can strike a blow for liberty, then I'll stick one in."
—JOHN WAYNE

"I like Wayne's wholeness, his style. As for his politics, well—I suppose even cavemen felt a little admiration for the dinosaurs that were trying to gobble them up."
—ABBIE HOFFMAN, 1960S POLITICAL ACTIVIST

Mark Rydell, the director of *The Cowboy* (1972), was at odds with Wayne over his right-wing principles. His original intention was for George C. Scott to play the role of Wil Andersen.

"Out here, due process is a bullet."
—JOHN WAYNE IN
THE GREEN BERETS (1968)

Problems with his heart and recovery from pneumonia made the production of *Brannigan* difficult. It proved to be one of Wayne's least successful movies at the box office.

In 1979, Maureen O'Hara introduced a petition for the formal recognition of Wayne's iconic status by the United States Congress. In turn he was awarded the Congressional Gold Medal, with the inscription "John Wayne, American."

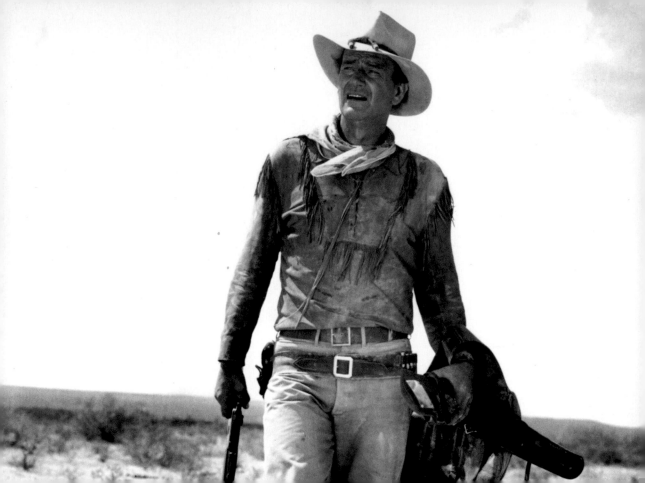

"There's been a lot of stories about how I got to be called Duke. One was that I played the part of a duke in a school play—which I never did. Sometimes, they even said I was descended from royalty! It was all a lot of rubbish. Hell, the truth is that I was named after a dog!"
—JOHN WAYNE

Wayne was a workhorse and at constant odds with his first wife, Josephine, about it. She had little interest in their film industry friends and colleagues, who had become staples in his everyday life.

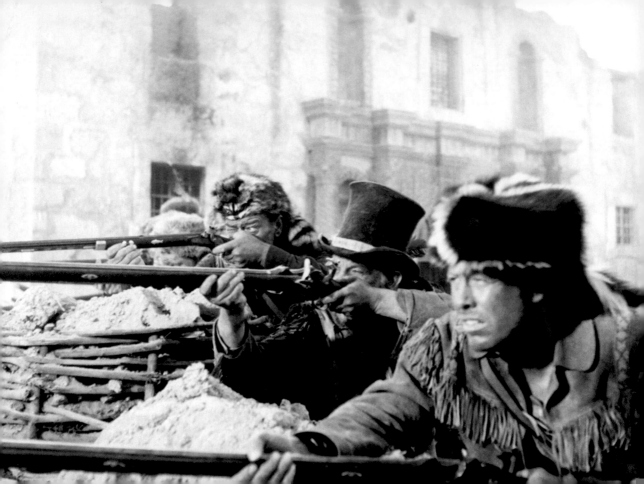

"This picture is America. I hope that seeing the battle of the
Alamo will remind Americans that liberty and
freedom don't come cheap. This picture, I guess making it has
made me feel useful to my country."
—JOHN WAYNE ON FILMING *THE ALAMO* (1960)

"There must be some higher power
or how else does all this stuff work?"
—JOHN WAYNE ON GOD

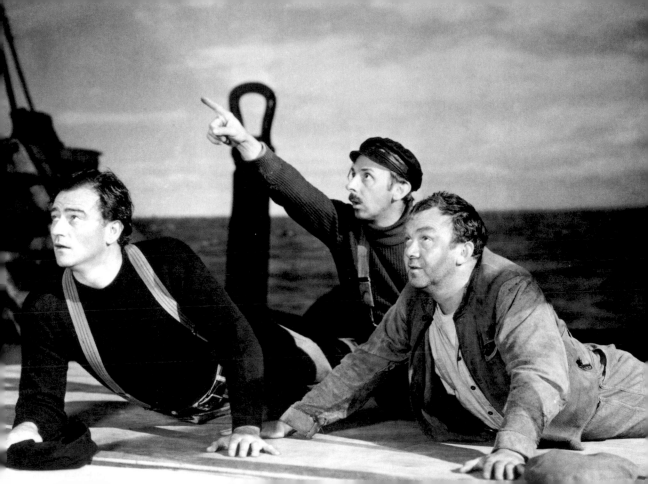

Along with Humphrey Bogart, Wayne was regarded as one of the heaviest smokers in Hollywood.

"There'll be no locked doors between us, Mary Kate Thorton."
—JOHN WAYNE IN *THE QUIET MAN* (1952)

By the 1960s, Wayne was commanding anywhere from $750,000 to $1,000,000 a picture, a far cry from the $3,700 he received for *Stagecoach*.

"There is no one who more exemplifies the devotion
to our country, its goodness, its
industry, and its strength than John Wayne."
—PRESIDENT RONALD REAGAN

"Do Not Stand at My Grave and Weep" by Mary Elizabeth Frye was read at John Wayne's funeral. The poem began, "Do not stand at my grave and weep. I am not there, I do not sleep."

"Tomorrow is the most important thing in life. Comes into us at midnight very clean. It's perfect when it arrives and it puts itself in our hands. It hopes we've learned something from yesterday."
—JOHN WAYNE

"Male menopause is a lot more fun than female menopause.
With female menopause you gain weight and get
hot flashes. Male menopause—you get
to date young girls and drive motorcycles."
—John Wayne

Wayne's first wife, Josephine Saenz, was the
daughter of a Panamanian Consul in Los Angeles. Josephine
was mother to four of his seven children.

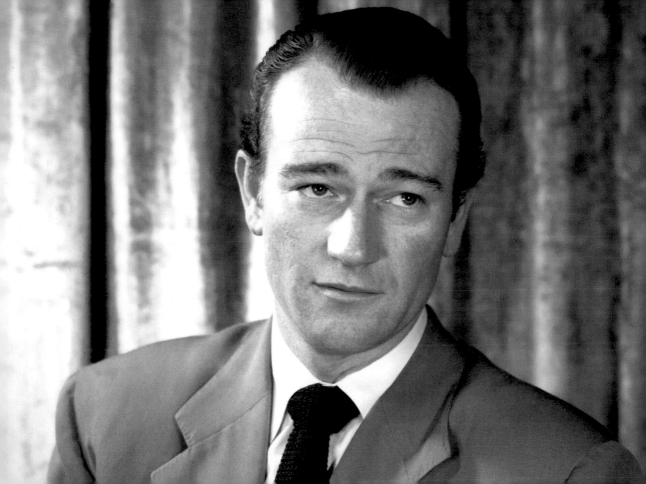

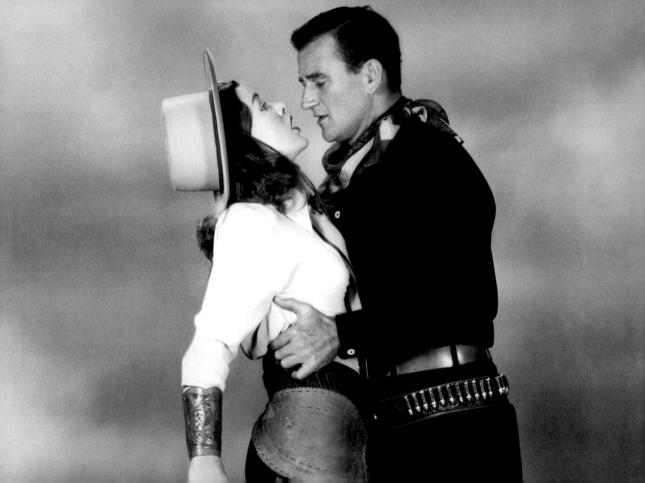

"My main duty was to ride, fight, keep my hat on, and at the end of shooting still have enough strength to kiss the girl and ride off on my horse or kiss my horse and ride off on the girl."
—JOHN WAYNE

Webb Overlander was John Wayne's makeup artist for
The Quiet Man. When he was told Overlander
would not be on set in Ireland, Wayne refused to start
filming until he was there.

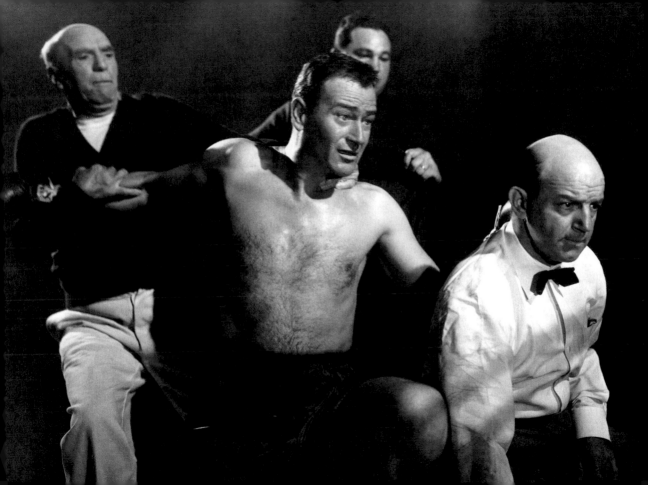

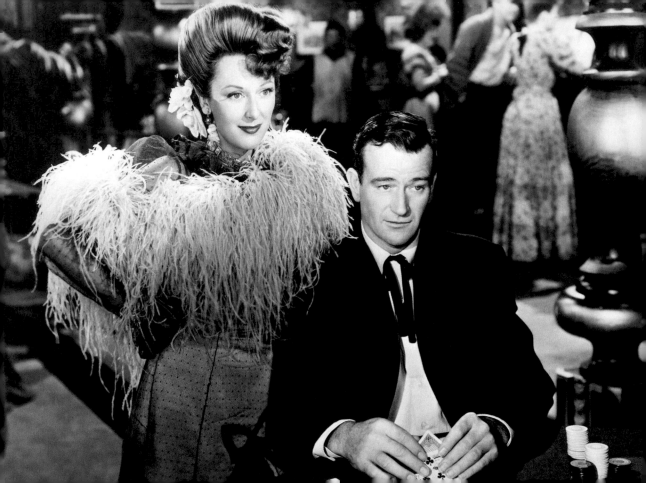

"Money never made an unhappy person happy, and
I'll be damned if losing money is going to make me miserable.
Hell, it's just money. I can make more."
—JOHN WAYNE

"Mine is a rebellion against the monotony of life."
—JOHN WAYNE

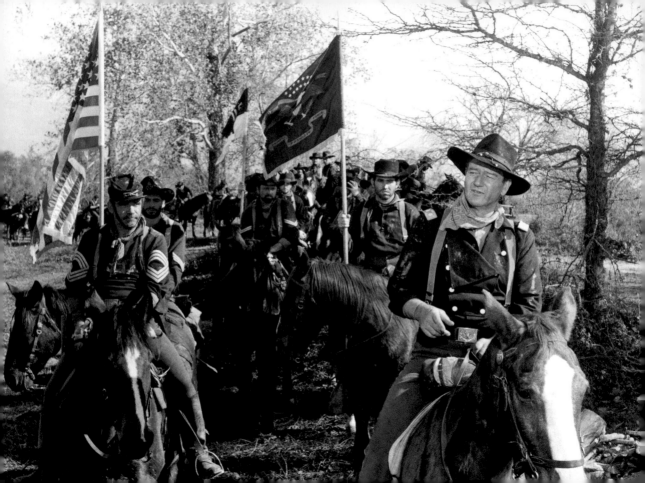

John Ford suspended location filming of *Horse Soldiers* (1959) in Louisiana after Fred Kennedy died while performing a riding stunt. The film was later completed in California.

Wayne was unhappy with the casting of Kim Darby as Mattie Ross in *True Grit*. Rumors abounded that the two actors barely spoke unless it was to film a scene. Tuesday Weld, Sally Field, and Sondra Locke had all turned down the role.

"As long as they're feminine,
I love them all—
plump, skinny, tall or short."
—JOHN WAYNE

"There are a lot of disgruntled girls around Hollywood who are sore at him for not succumbing to their charms . . . and when his wife is not with him, he'll stay up all night reading or arguing about movie making and politics."
—JAMES GRANT, SCREENWRITER

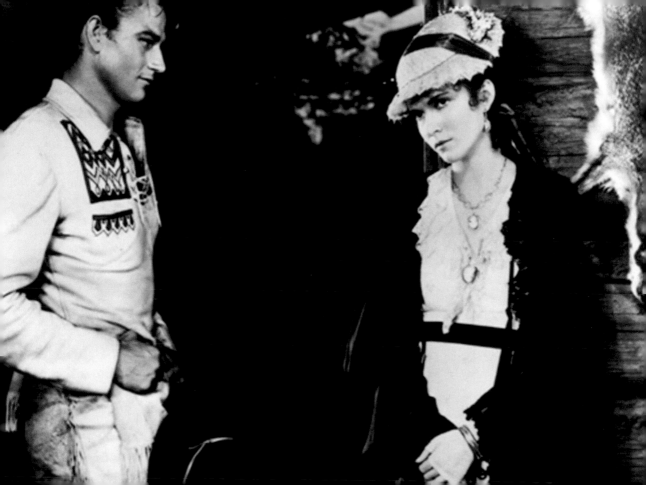

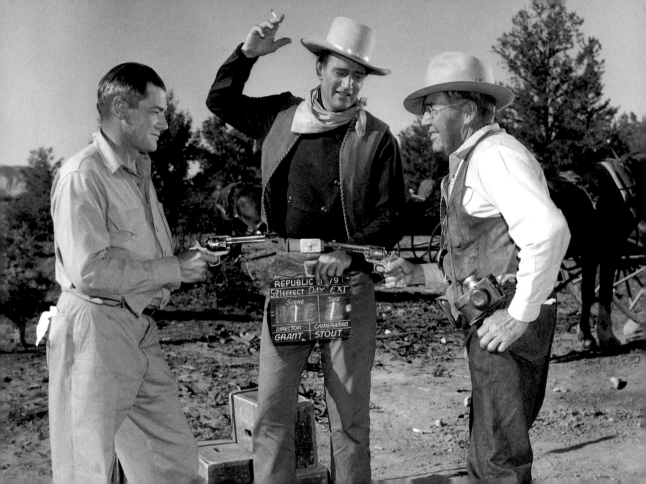

Director Frank Capra quit the filming of *Circus World* (1964) when Wayne insisted that close friend and screenwriter James Grant be brought in to rewrite the script.

"And speaking of politics, where we're going there are only two parties: the quick and the dead."
—JOHN WAYNE IN *DAKOTA* (1945)

"As an actor he has an extraordinary gift. A unique naturalness. A very subtle capacity to think and express and caress the camera— the audience. A secret between them."
—KATHARINE HEPBURN

Wayne's rise to being the quintessential movie war hero began to take shape four years after World War II when *Sands of Iwo Jima* was released. His footprints at Grauman's Chinese theater in Hollywood were laid in cement that contained sand from Iwo Jima.

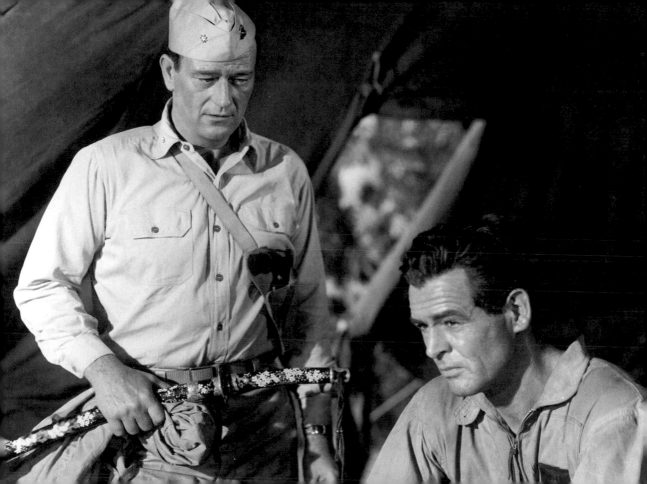

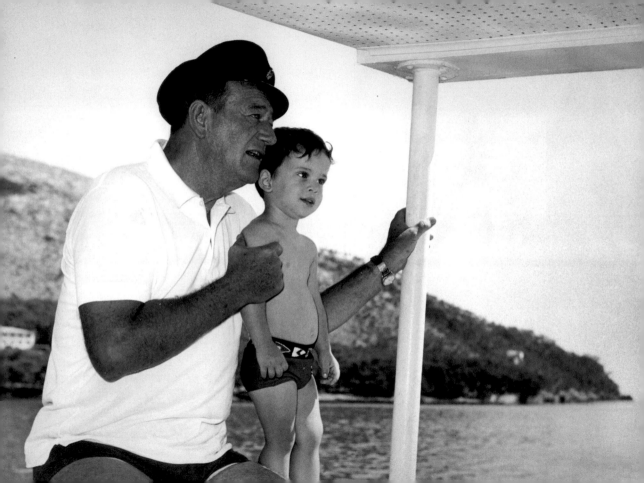

"Being the son of John Wayne has just been the greatest. I couldn't imagine being the son of anybody else. He was a great dad and a great friend and he gave me incredible opportunities."
—PATRICK WAYNE, JOHN'S SON

"Because of his courage, his dignity, his integrity, and because of his talents as an actor, his strength as a leader, his warmth as a human being throughout his illustrious career, he is entitled to a unique spot in our hearts and minds."
—ROBERT ALDRICH, THEN PRESIDENT OF THE DIRECTOR'S GUILD OF AMERICA.

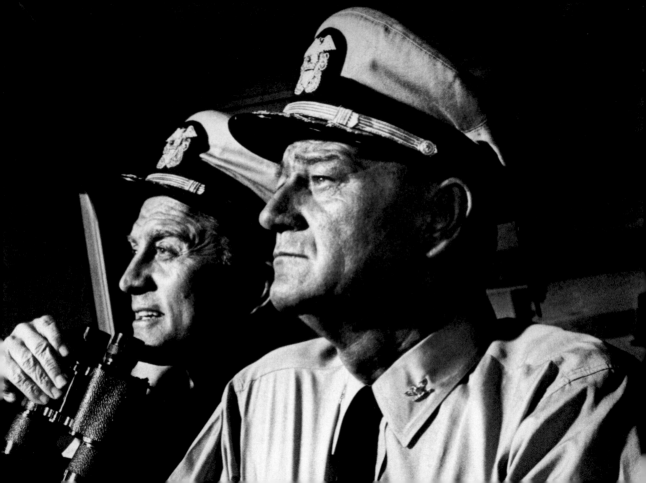

Wayne's costar in *In Harm's Way* was a young Kirk Douglas as Commander Paul Eddington Jr. Wayne and Douglas later costarred again in *The War Wagon*, and Wayne had a cameo in Douglas's ode to Israel, *Cast a Giant Shadow* (1966).

During filming of *Cast A Giant Shadow* (1965), Wayne had the script rewritten. Director Melville Shavelson continued to use the old script when Wayne was not filming and allowed Wayne to use the new script for his scenes. Wayne eventually found out and threatened Shavelson. The rewrite was used from that point on.

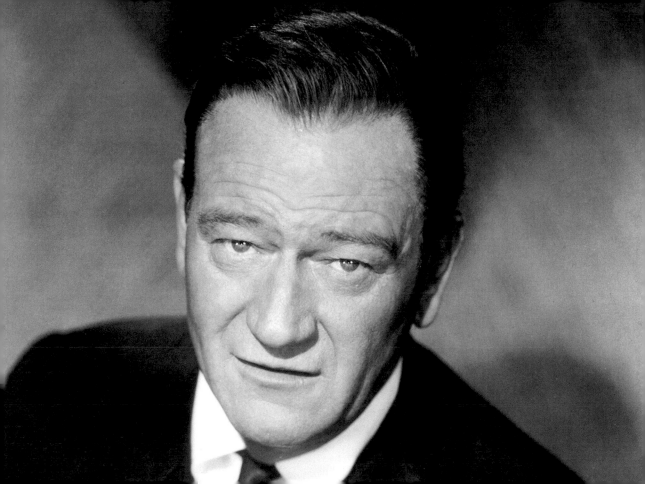

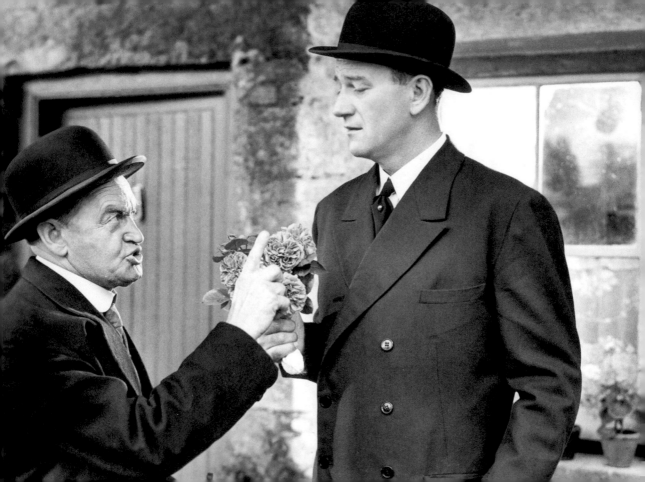

"Talk low, talk slow and don't talk too much."
—JOHN WAYNE

"I hated the countryside when
I was a kid. The only reason I'd go off on my own was to
run away from home because there was . . . well,
a lot of unhappiness back there."
—John Wayne

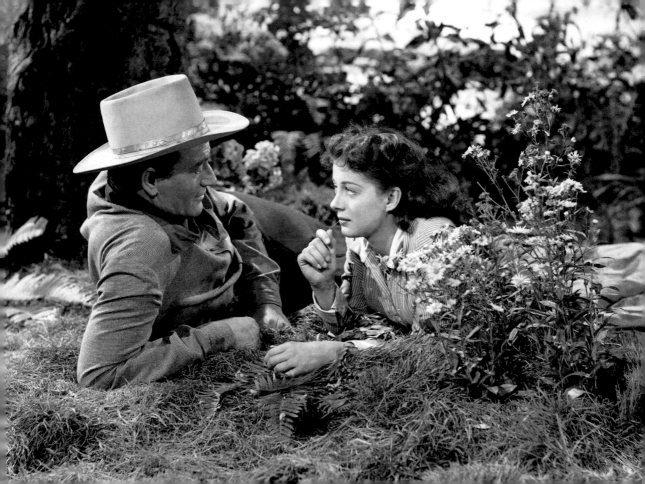

"Find me someone as famous as Mr. Wayne to speak in favor of the war and we'll book him."
—MERV GRIFFIN TO CBS EXECS WHEN THEY COMPLAINED THAT WAYNE WAS GRIFFIN'S ONLY PRO-WAR GUEST.

"Sure I wave the American flag. Do you know a better one?"
—JOHN WAYNE

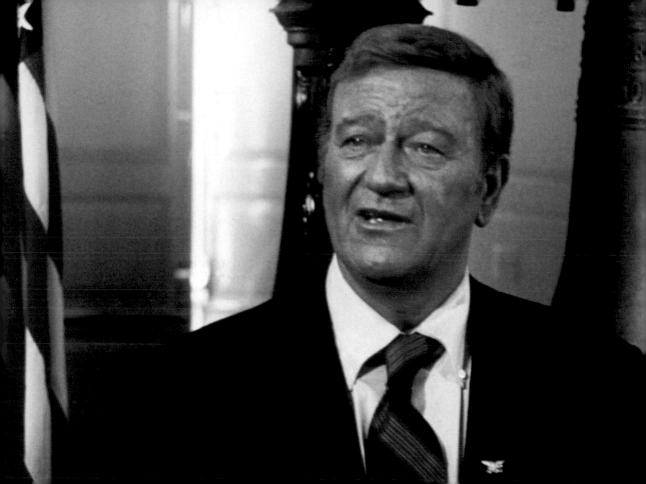

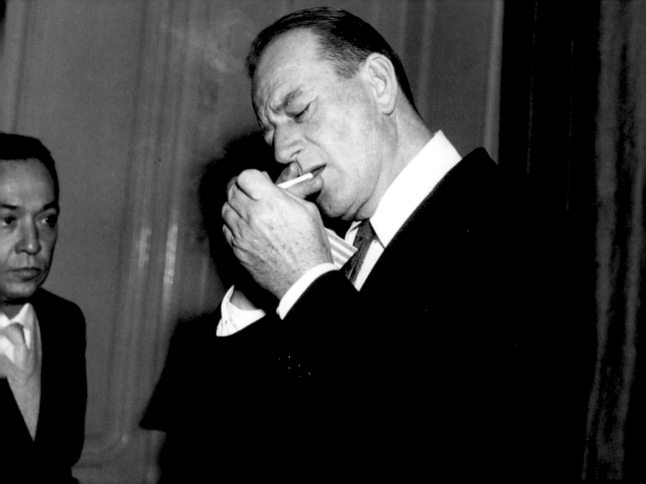

"It's a foolish weakness, but not smoking is the hardest thing in the world for me. I guess it's because I've been smoking since I was a kid."
—JOHN WAYNE

"It's kind of a sad thing when a normal love of country makes you a super patriot. I do think we have a pretty wonderful country, and I thank God that He chose me to live here."
—JOHN WAYNE

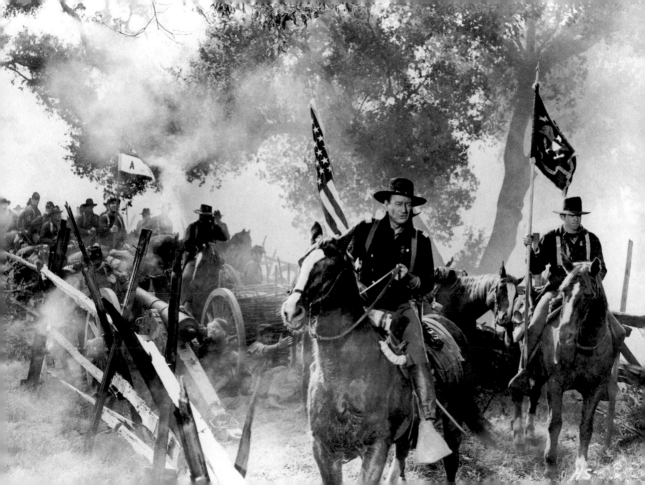

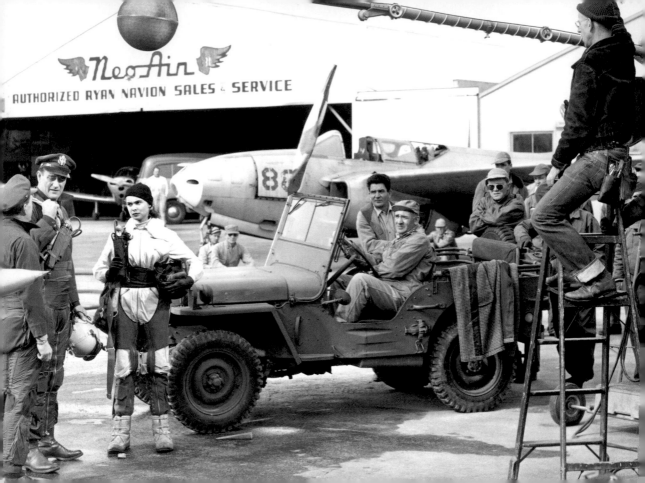

As he had done for Michael Curtiz years earlier, Wayne took the
director's seat when director George Sherman fell
ill during the filming of *Big Jake* (1971). He again refused
full credit and received codirector billing.

"I've gotten damn few roles where you could get your teeth into and develop a character. Until Rooster [in *True Grit*], I haven't had a role like that since *The Searchers* [1956]."
—JOHN WAYNE

"It is undoubtedly one of my worst movies ever."
—JOHN WAYNE ON *JET PILOT* (1957)

The Red River (1948) drew a then-staggering $4.5 million dollar box office. That would be equal to roughly $40 million today.

"I never knew the big son of a bitch could act."
—JOHN FORD ON WAYNE'S
PERFORMANCE IN *RED RIVER*

John Wayne released four films in 1948: *Fort Apache*, *Red River*, *Three Godfathers*, and *Wake of the Red Witch*.

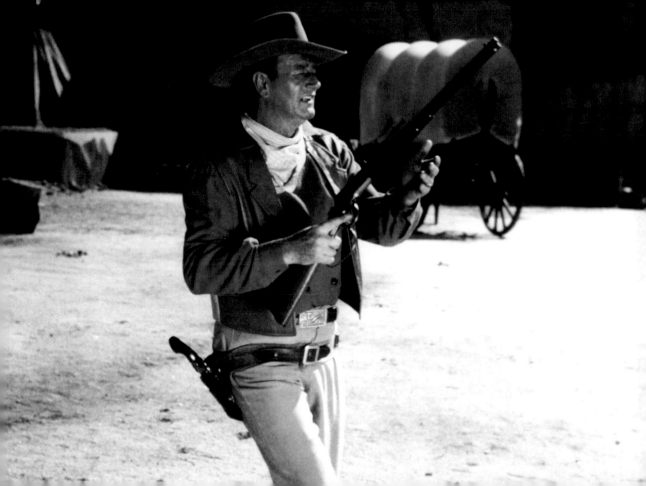

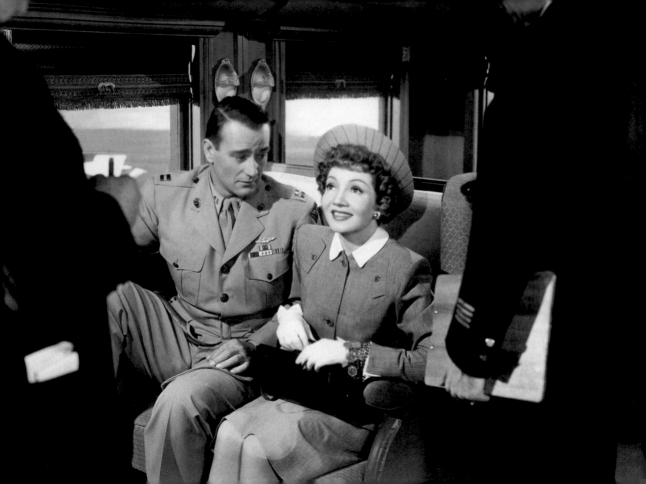

Claudette Colbert was the last person to be billed above John Wayne in any film. Wayne took top billing in every single film he made after *Without Reservations* (1946), other than cameos and guest appearances.

"I never had a goddamn artistic problem in my life, never, and I've worked with the best of them. John Ford isn't exactly a bum, is he? Yet he never gave me any manure about art. He just made movies and that's what I do."
—JOHN WAYNE

"Young man, you represent the cavalry officer
more than any man in uniform."
—GENERAL DOUGLAS MACARTHUR AFTER
SEEING *RIO GRANDE* (1950)

"I don't act . . . I react."
—JOHN WAYNE

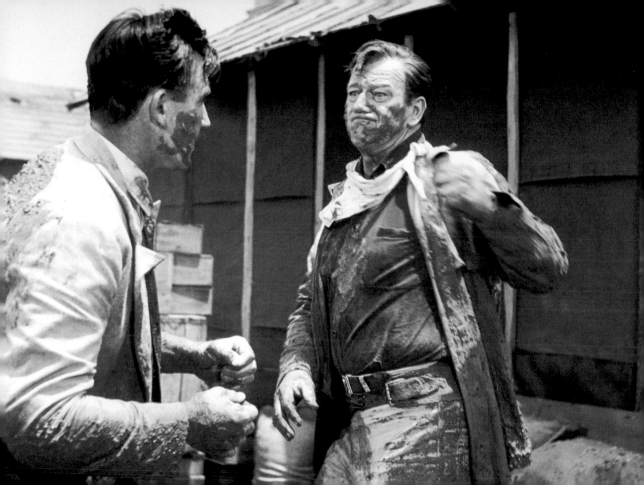

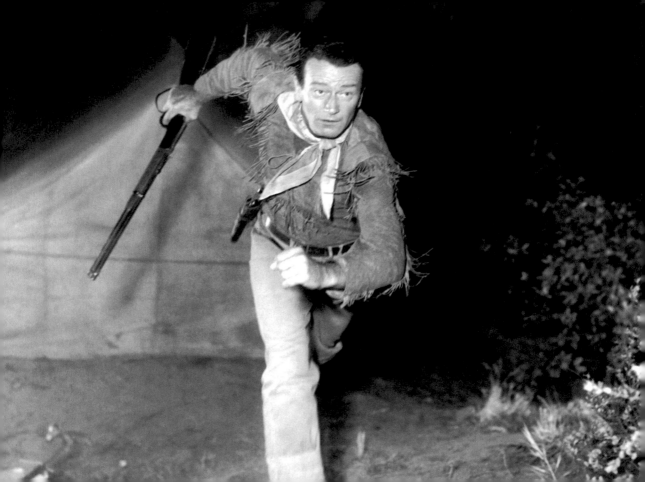

Hondo was originally intended to be a John Wayne production, starring Glenn Ford. Ford and director John Farrow had such a disagreeable experience working together on *Plunder of the Sun* (1953), Wayne instead cast himself.

"No man's lifetime of work has better expressed the land of the free and the home of the brave. No man's lifetime of work has given proof to the world that our flag is still there. John Wayne is in truth a star-spangled man whom so proudly we hail."
—FRANK SINATRA

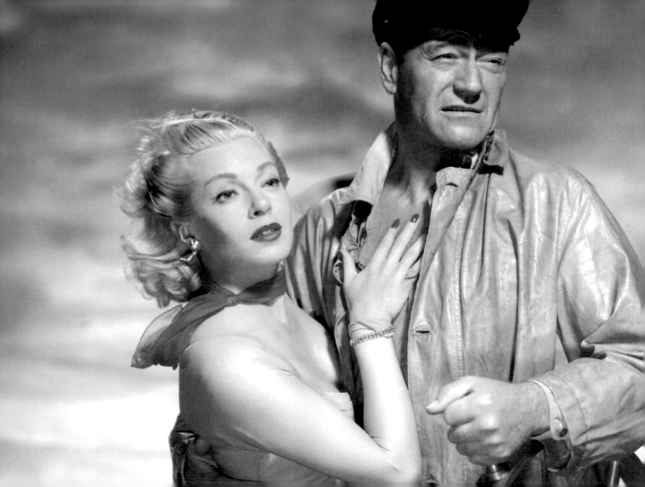

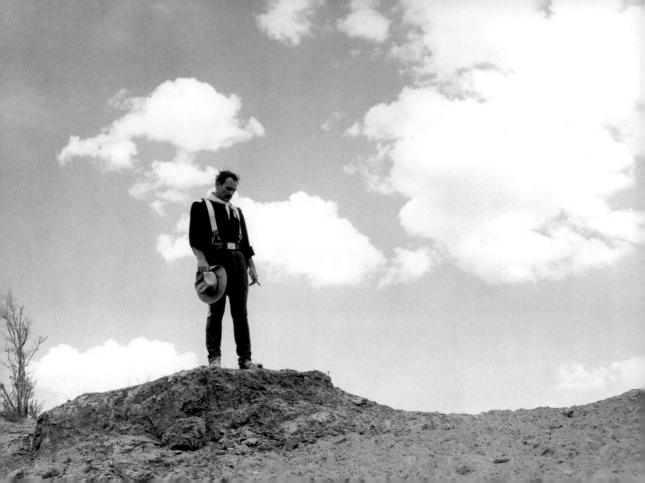

"I just couldn't see myself lying in bed, not
being able to help myself. That,
to me, was worse than the fear of death."
—JOHN WAYNE ON BEING TOLD
HE HAD CANCER

"Sure I love my country with all her faults. I'm not ashamed of that, never have been, never will be."
—John Wayne

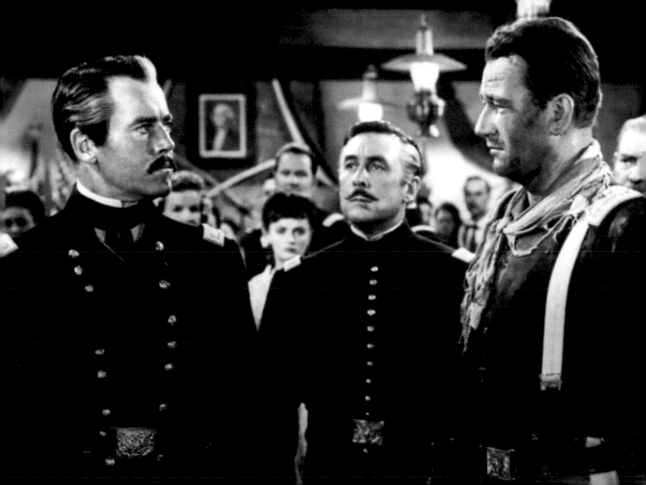

"I can't be in this picture, it's too dirty . . . but
I'll be the first in line to see it."
—John Wayne to Mel Brooks on the script
to *Blazing Saddles* (1974)

"Success is not measured by your wealth, but in your worth Honorable men and women have a right to stand up for the things they hold dear . . . It's the American way."
—JOHN WAYNE

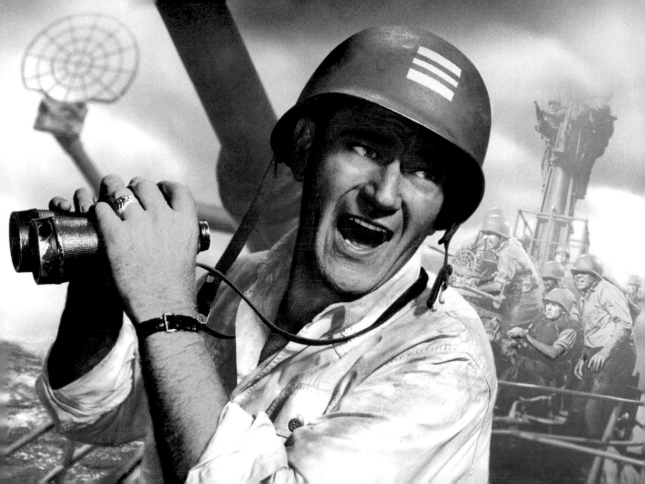

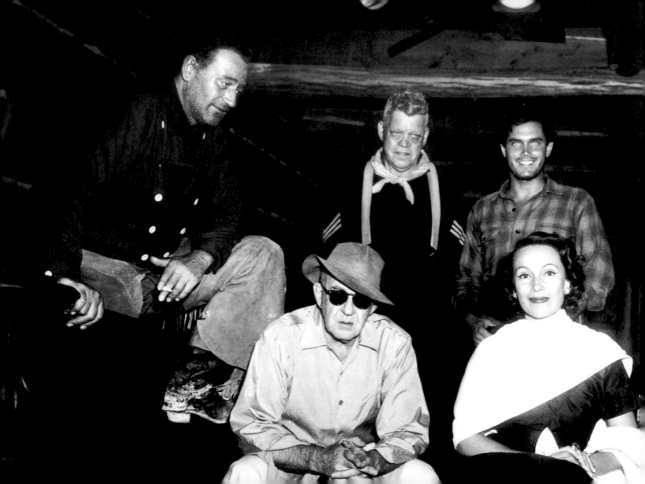

Because of their constant use by John Ford, John Wayne, Harry Carey, John Carradine, Henry Fonda, and others became a group of actors known as the John Ford Stock Company. Wayne referred to him as "Coach."

"I am a demonstrative man, a baby picker-upper, a hugger
and a kisser—that's my nature."
—JOHN WAYNE

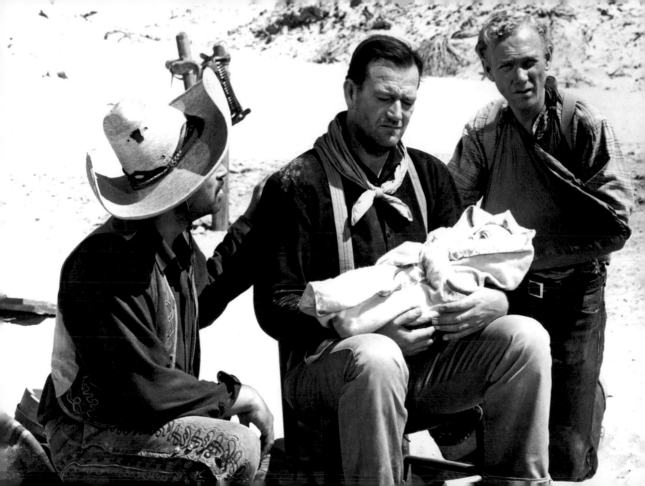

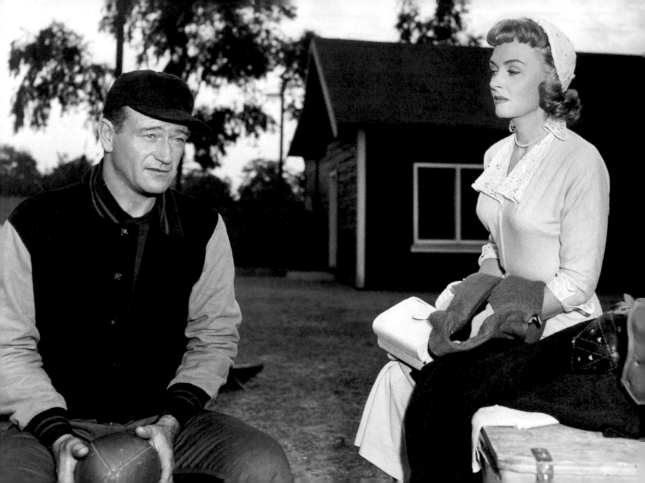

"Winning isn't everything, it's the only thing."
—JOHN WAYNE IN *TROUBLE ALONG THE WAY* (1953)

"I have never been in trouble or needed help at any time in my
life that I didn't first pick up the phone and call Duke,
and within five minutes I had what I wanted or what I requested,
or what I needed. And he never asked for a thank you. He
wouldn't think of that . . . He has a very soft heart and if you do
make a mistake, he will bend those rules, not for himself, but to
forgive you. And that is friendship and love."
—MAUREEN O'HARA

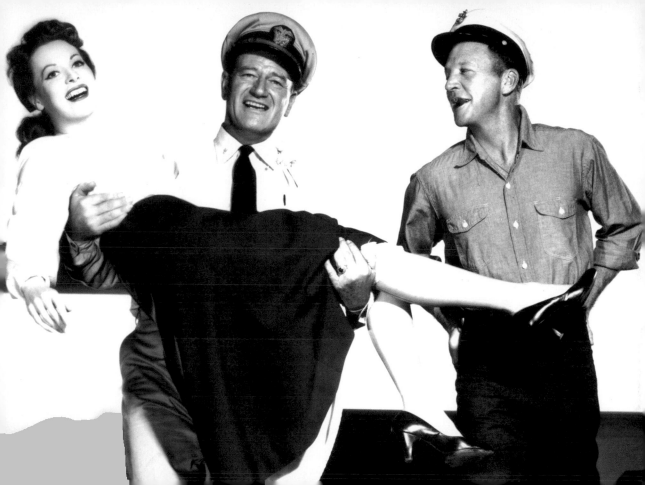

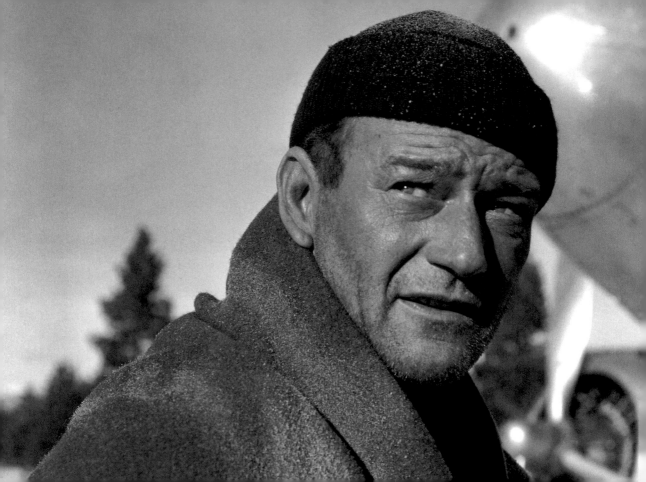

Wayne used a Spanish adage when asked how he wanted to be remembered: *Feo, Fuerte, y Formal*. Translation: "He was ugly, strong, and had dignity."

The Duke played a Centurion at the crucifixion of Christ in *The Greatest Story Ever Told*. Though already a seasoned actor at the time of its filming in 1965, the script called for a single line: "Aw, truly this man was the son of God."

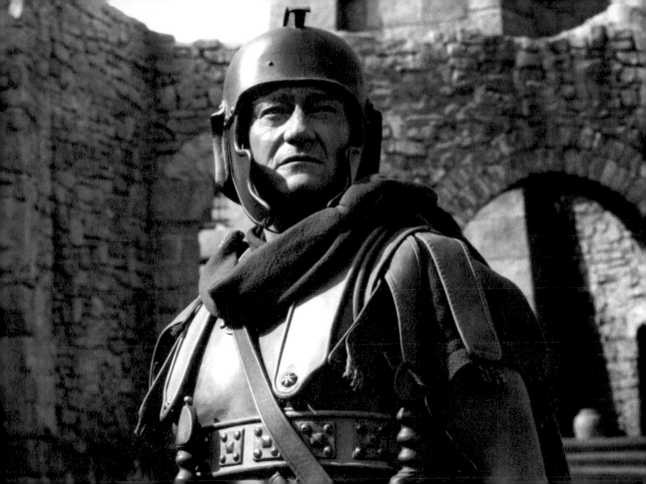

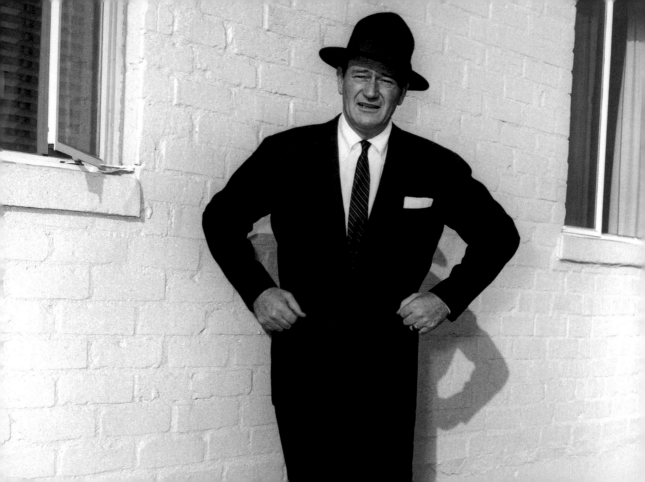

Turning down a proposition from Democratic Alabama Governor George Wallace, Wayne campaigned vigorously on the part of Richard Nixon in 1968. He would also go on to speak at the Republican National Convention in August 1968, its opening day.

"Republic. I like the sound of the word."
—JOHN WAYNE IN *THE ALAMO* (1960)

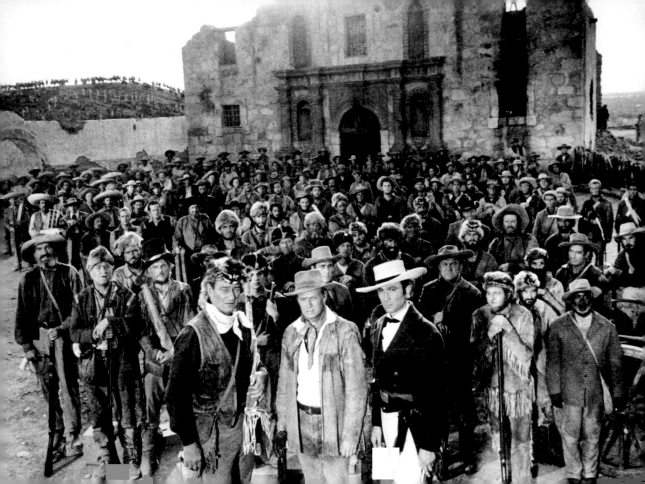

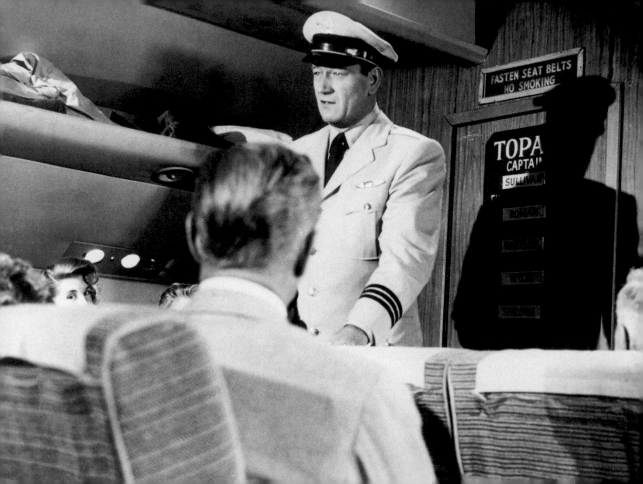

Dan Roman, John Wayne's role in *The High and Mighty* (1954), was originally offered to Spencer Tracy. Tracy was an avowed Democrat and refused the role, wanting no ties to a John Wayne–produced picture.

"I play John Wayne in every part regardless of the character, and I've been doing okay, haven't I?"
—JOHN WAYNE

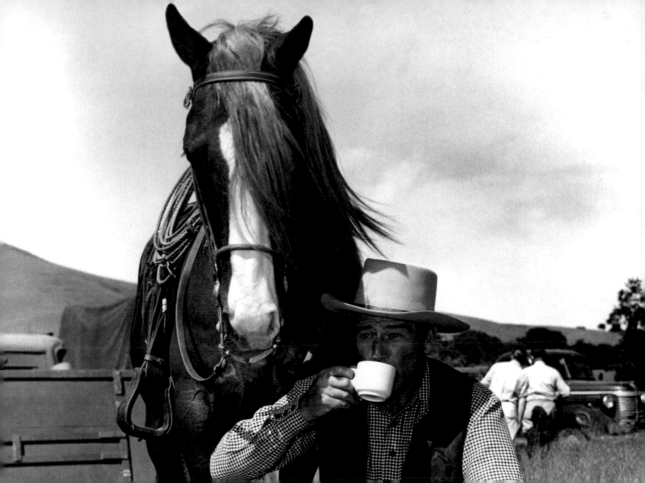

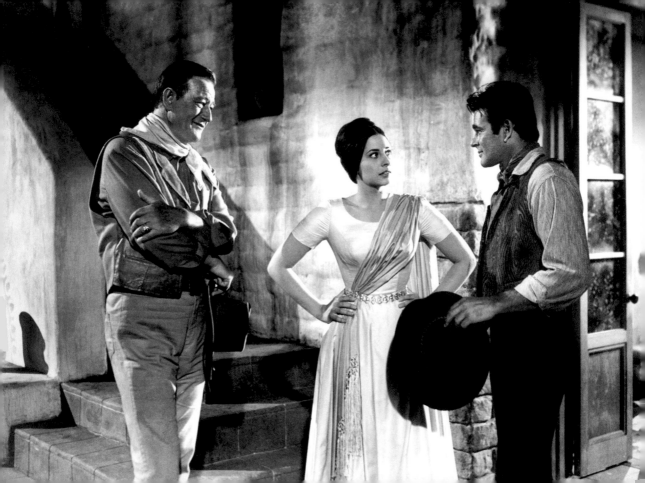

When Director Michael Curtiz fell too ill to work due to cancer, Wayne took the director's chair for most of *The Comancheros* (1961). He refused to receive a codirector credit as acknowledgment.

Director Don Siegel, of *Dirty Harry* (1971) fame, had found an impressed fan in Wayne. There are conflicting reports concerning the role that made Clint Eastwood famous. Some say the Duke turned down the role, later to regret it; others say that he was never offered the part due to his age, then 68.

"I know what the critics think—that I can't act. What is a great actor anyway? Of course, you could say a great actor is one who can play many different parts, like [Laurence] Olivier can. But all the parts I play are tailor made for me."
—JOHN WAYNE

Though the Howard Hughes–produced *Jet Pilot* was wrapped up
filming in the late 1940s, it had been deemed too ahead
of its time. It did not receive clearance from the U.S. Air Force
until 1957 to be viewed in the box office.

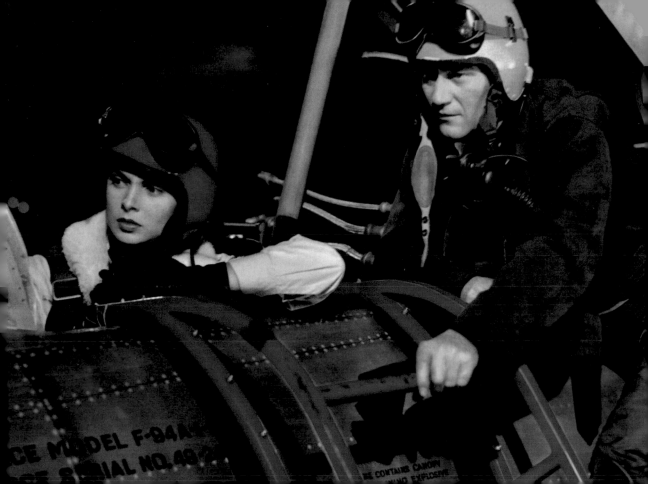

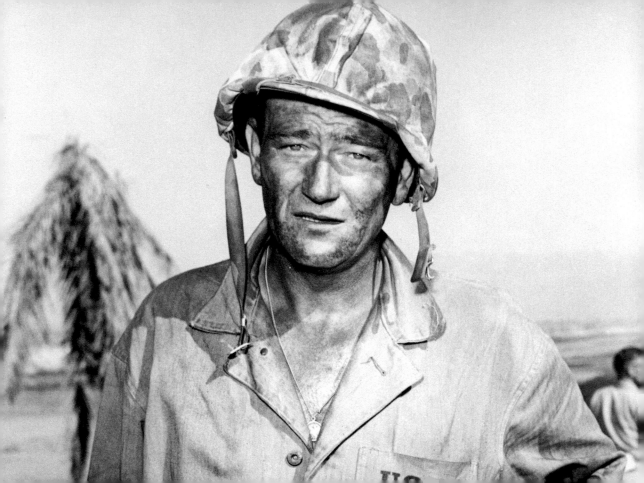

"I never felt I needed to apologize for my patriotism."
—JOHN WAYNE

"I love working with Duke, but he tells everyone what
to do, bosses everyone around,
and I'm the one that usually gets to do that."
—KATHARINE HEPBURN

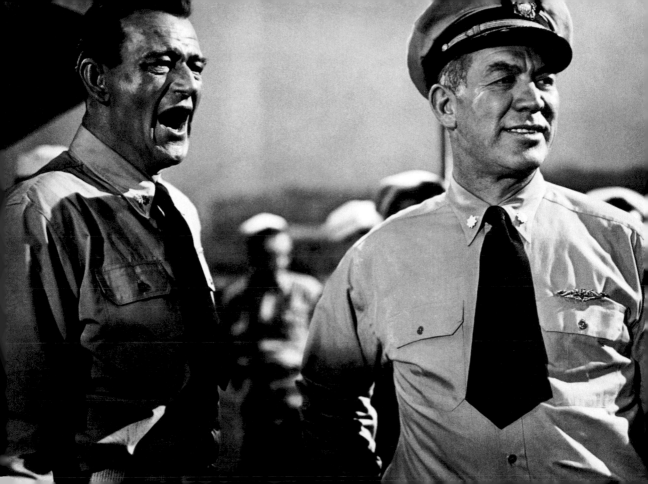

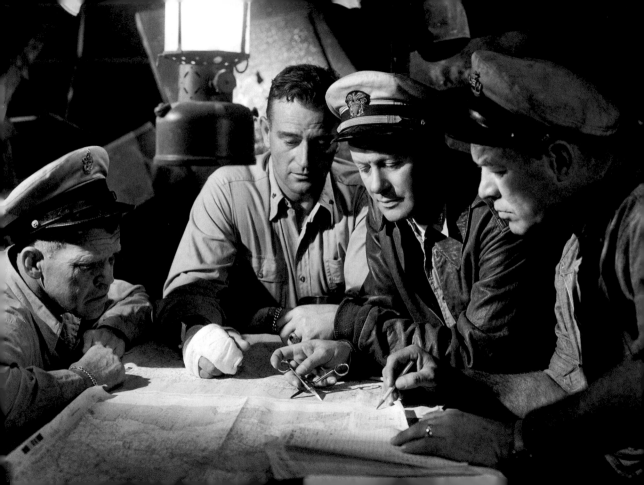

They Were Expendable (1945) takes its story from a book based on the real-life exploits of John Bulkeley, a World War II Medal of Honor recipient, and his colleagues. Even though the film closely follows the book's plot, some of the people portrayed sued the filmmakers. This eventually led to the addition of the now-familiar disclaimer that appears before a film is shown: "All characters are fictional. Any resemblance to actual people is purely by coincidence and any of their actions in actual historical events is not accurate."

"I never trust a man that doesn't drink."
—JOHN WAYNE

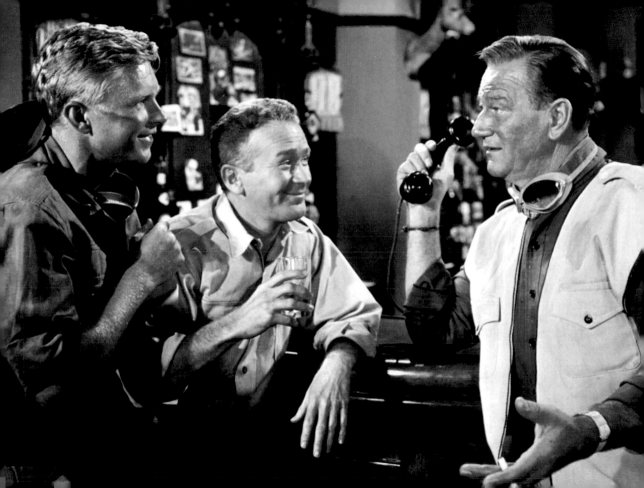

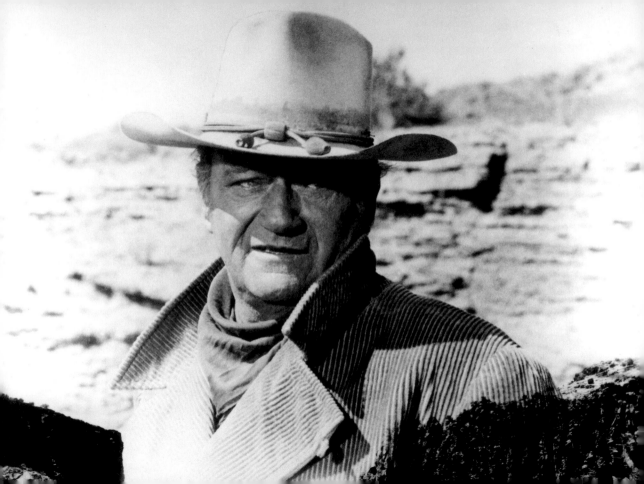

The Duke's 100th birthday was celebrated in 2007 at the National Cowboy and Western Heritage Museum. It commenced with a dedication of a sculpture in his likeness to the Western Heritage Museum.

"Contrary to what people think, I'm no politician, and when I have something to say I say it through my movies."
—JOHN WAYNE

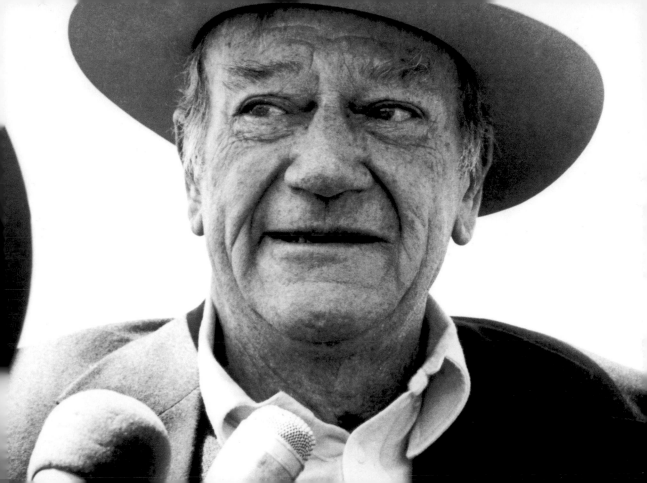

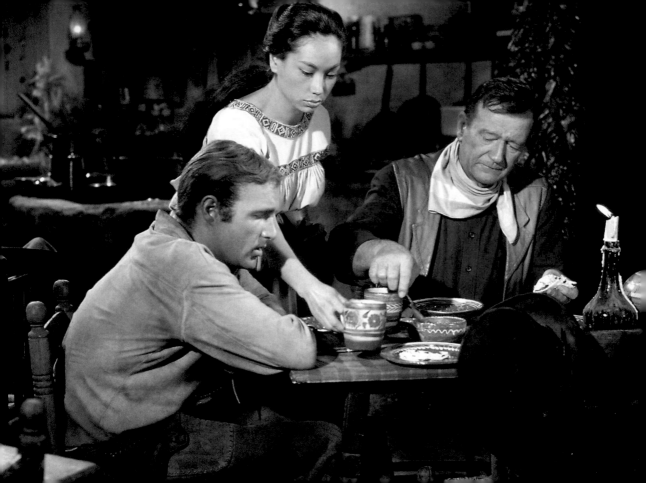

Though critics and fans alike bashed *El Dorado* (1966), it proved to be wildly successful in theaters. The title is based on the poem "El Dorado" by Edgar Allan Poe. The character Mississippi recites it in the film

"I never want to play silly old men chasing young girls."
—JOHN WAYNE

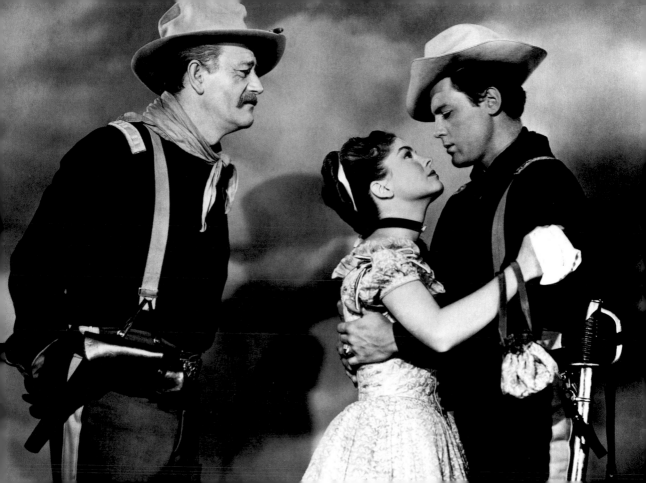

"I have tried to live my life so that my family would
love me and my friends respect me.
The others can do whatever the hell they please."
—JOHN WAYNE

"He was a caring man, a selfless man. Thinking back after all
these years, I don't think my mother, God rest her
soul, deserved him. I only wish I'd
learned then to let him know how much I loved him."
—John Wayne, on his father, who died
of a heart attack in 1937

"I have certain feelings about what I do. I like to play a character that a large number of people can identify with. Whether it's that they can say he's their father, uncle, brother, or whatever. It's human dignity . . . nothing mean or petty, cruel or rough. Tough, that's all right."

—John Wayne

"The fire is not discriminating. It burns anything in its path for whatever reason."
—John Wayne

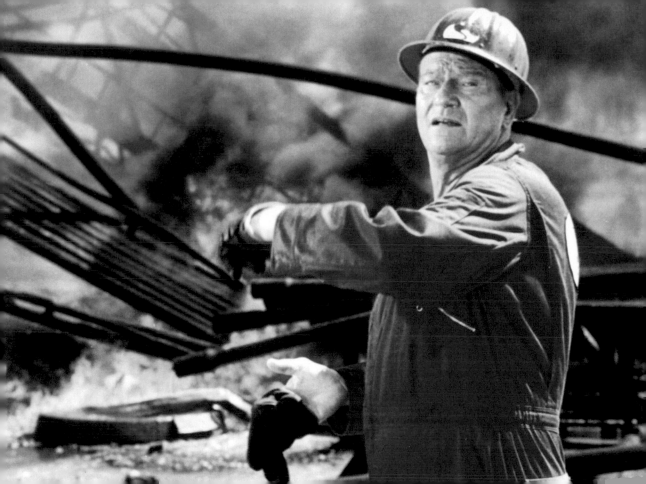

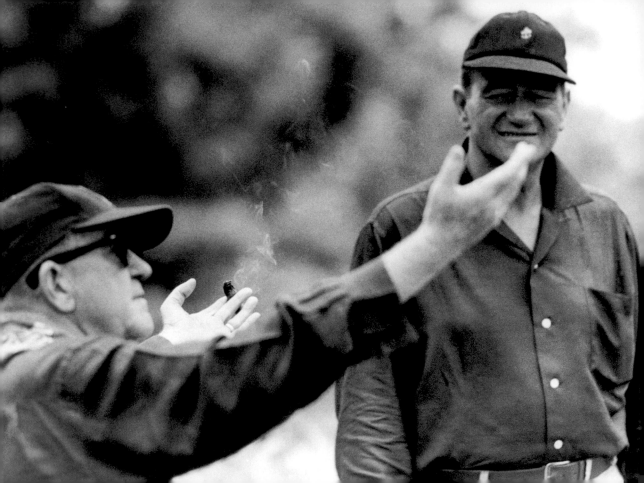

1963's *Donovan's Reef* was the last film from actor-director team John Wayne and John Ford. They had been working together since *Stagecoach* in 1939.

"Courage is being scared to death—and saddling up anyway"
—JOHN WAYNE

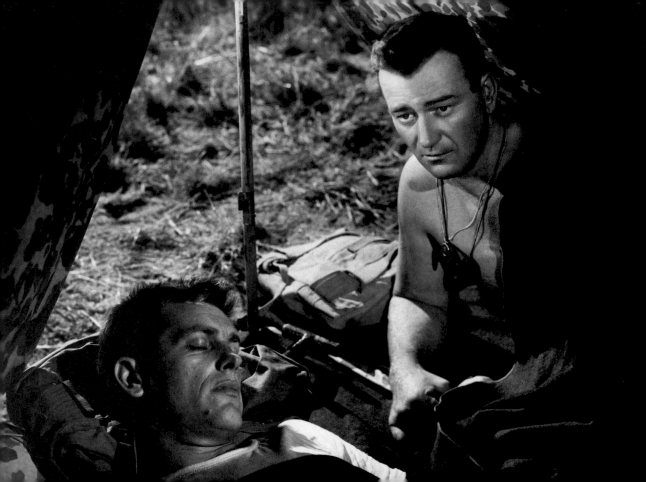

John Wayne was first nominated for an Oscar for *Sands of Iwo Jima* in 1949, only to lose to Broderick Crawford for *All The King's Men*. He finally beat out all the competition with the part of Rooster Cogburn in *True Grit* in 1969.

"Do you know any better way to learn respect from someone than to have him cross the line of scrimmage from you? Do you think that the color of your skin or the amount of your father's property or your social position helps you there?"
—JOHN WAYNE

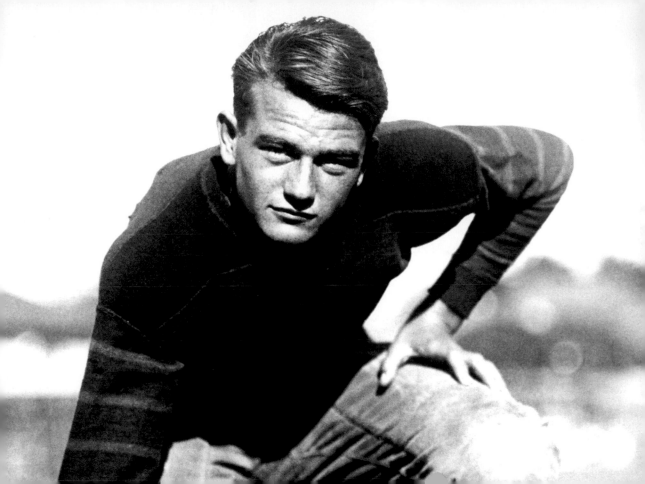

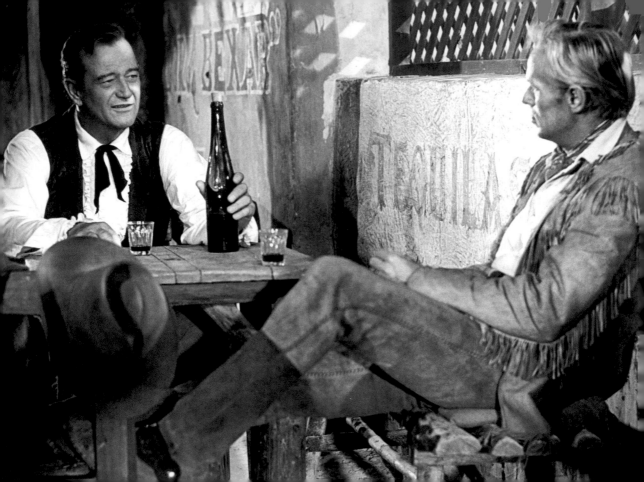

"Give me a fifth of bourbon—that'll square it."
—JOHN WAYNE, DISCUSSING PAYMENT TERMS FOR HIS GUEST
APPEARANCE ON *THE BEVERLY HILLBILLIES*

Wayne was at the forefront of supporters of right-wing politics. He backed Ronald Reagan's successful campaigns for governor of California in 1966 and 1970, as well as his bid for the Republican presidential nomination in 1976.

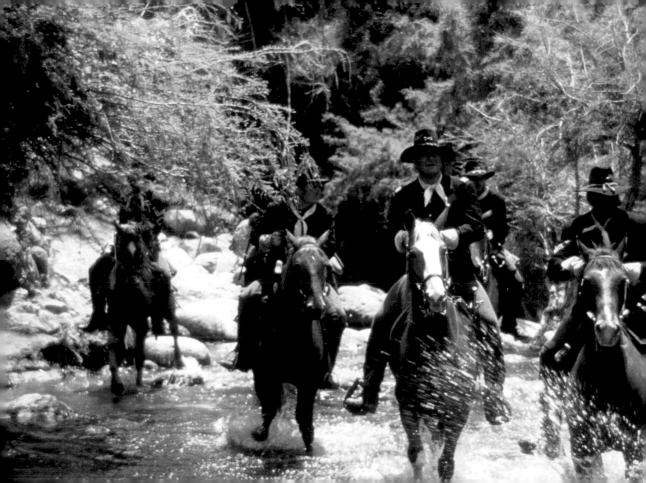

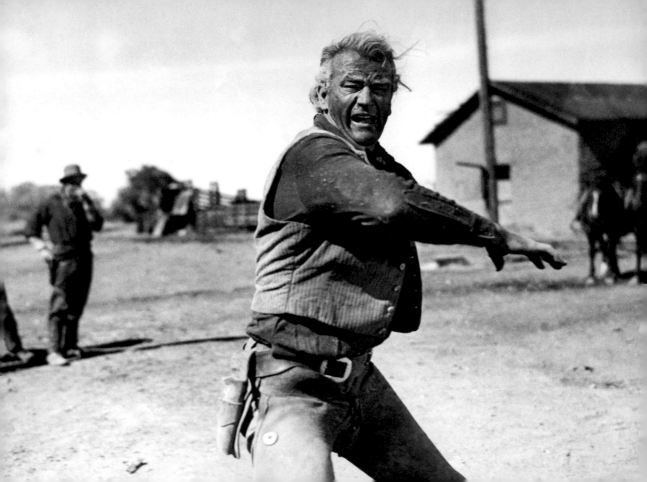

"I won't play anybody dishonest or cruel or mean for no reason. I've killed men on the screen, but it was always because they didn't follow the code."
—JOHN WAYNE

"I won't be wronged, I won't be insulted, and I won't be laid a hand on. I don't do these things to other people and I expect the same from them."
—JOHN WAYNE IN *THE SHOOTIST*

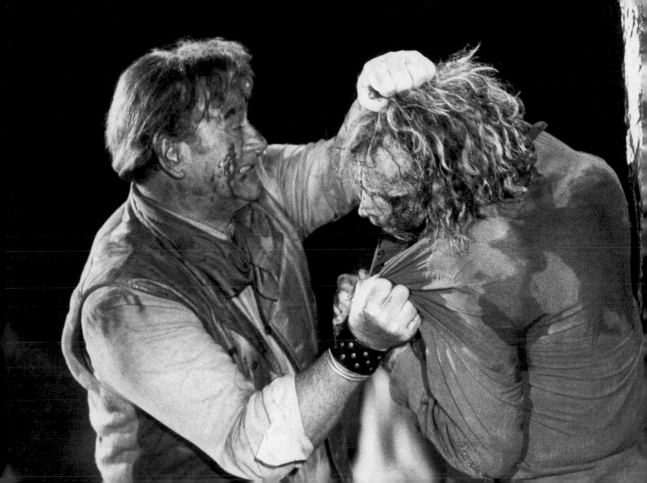

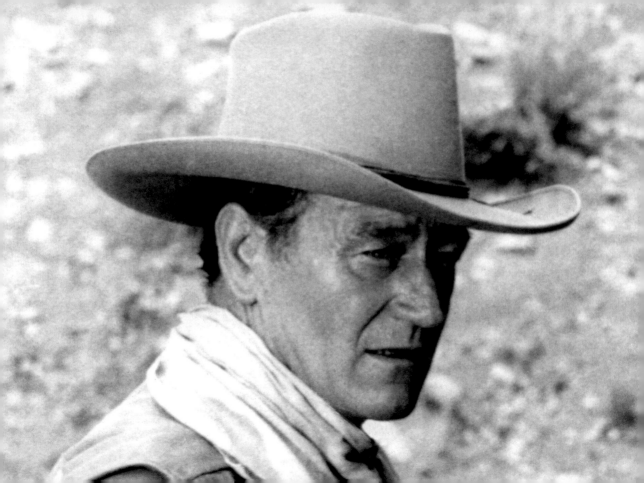

Bo Christian Roos became his business manager from 1941 to 1959. During that period, he squandered his fortune with bad investing and over-the-top, lavish spending.
"I suddenly found out after 25 years I was starting out all over again. I would just about break even if I sold everything right now."
—JOHN WAYNE

"When I'm getting serious about a girl, I show her
Rio Bravo and she better fucking like it."
—QUENTIN TARANTINO

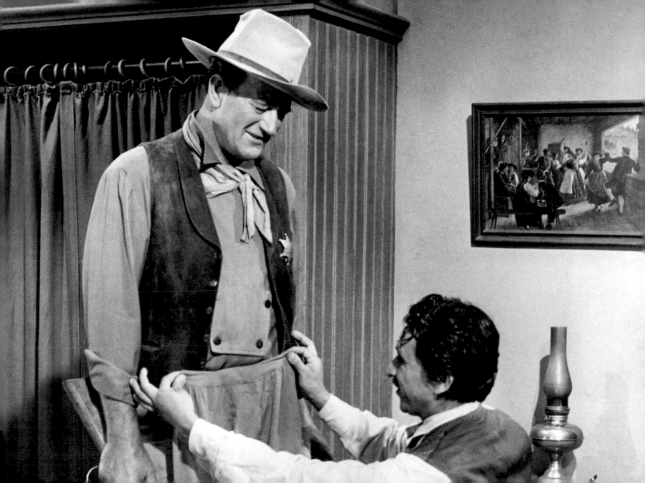

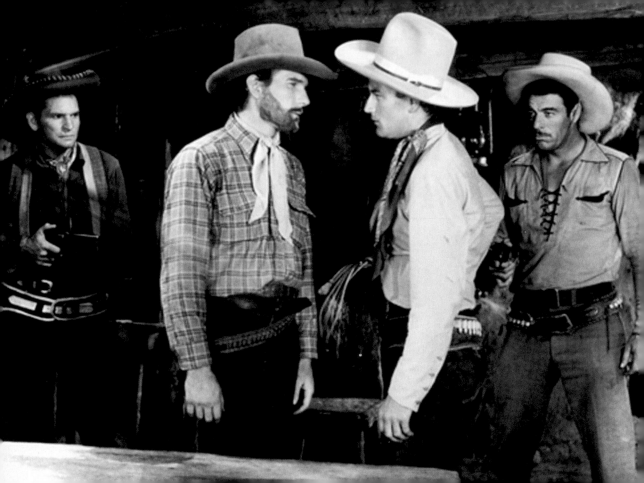

"I want to play a real man in all my films, and I define manhood
simply: men should be tough, fair, and courageous;
never petty, never looking for a fight,
but never backing down from one either."
—JOHN WAYNE

In between takes on the set of *El Dorado*, John Wayne and James Caan got into a dispute over a game of chess. Caan thought Wayne was cheating; the disagreement was settled with the help of costar Robert Mitchum.

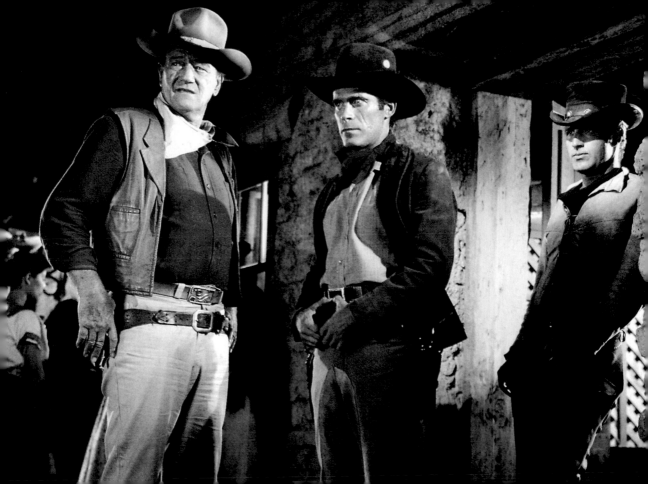

"I had the feeling my career was going to decline back in '68. Then I read a script for a film called *True Grit*."
—John Wayne

"He was a big, big chunk of America. Wayne meant a lot to America. He loved to promote America. He stood for America. I don't think he saw himself as a symbol. He just wanted to do the things he wanted to do, and those things were right for America."

—BOB HOPE

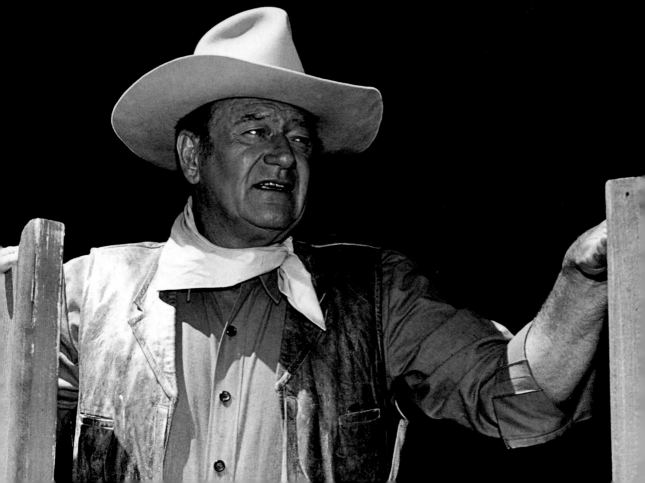

John Wayne passed away of stomach cancer at 72 years old,
on June 11, 1979.

"My problem is I'm not handsome like Cary Grant . . .
who will be handsome at 65."
—JOHN WAYNE

"I'm a greedy old man. Life's been good to me, and I want some more of it."
—JOHN WAYNE

Five stars turned down *The Shootist* before Wayne took on the role of J. B. Books, his last. To create a sense of authenticity for the character, footage from *El Dorado*, *Rio Bravo*, *Hondo* (1953), and *Red River* were used in the opening credits as an introduction.

"I understand my fans because I had idols. They were Harry Carey and Tom Mix."
—JOHN WAYNE

"I'm a progressive thinker, even though
I'm not in the liberal strain."
—JOHN WAYNE

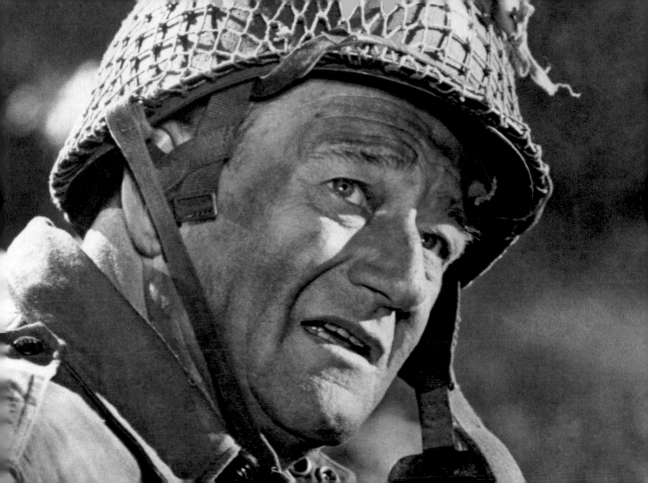

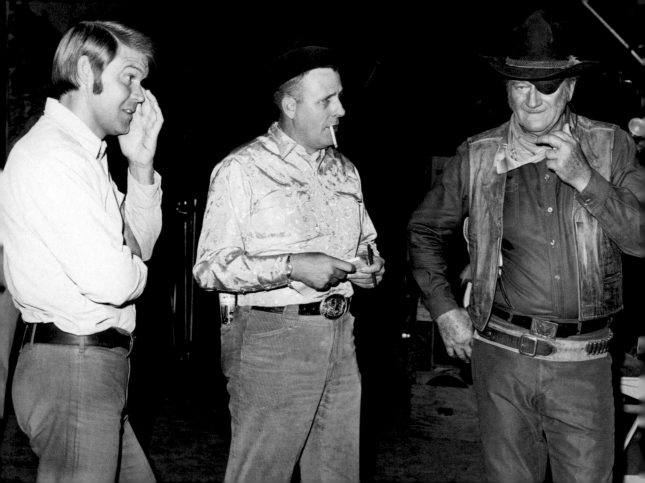

For the role of Colonel John Henry Thomas in *The Undefeated*, John Wayne had to lose a majority of the weight he acquired in order to play Rooster Cogburn in *True Grit*.

Cast a Giant Shadow (1966) was based on a true story. It was filmed in the Middle East, exactly where the historical events took place. It was the film debut of Kirk Douglas.

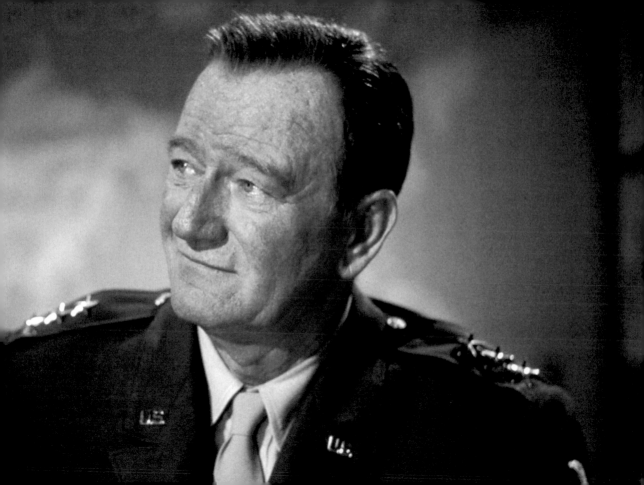

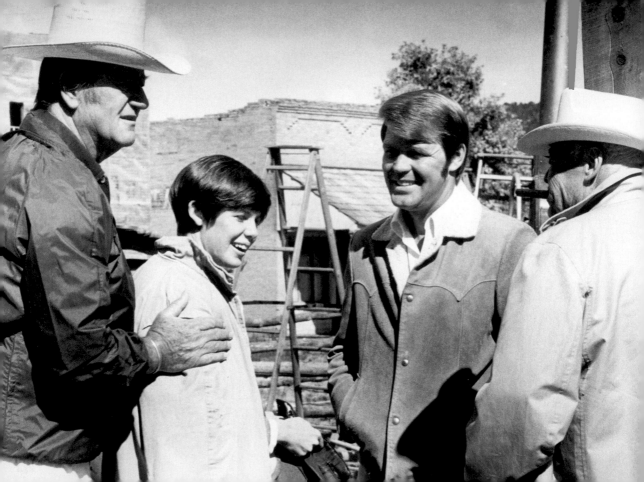

Elvis Presley was considered for a role in True Grit. Friction between his management and the filmmakers over giving him top billing led to Glen Campbell being cast in the role instead.

"I think women's lib is fine, as long as they're home by six to cook my dinner."
—JOHN WAYNE

"If it is for the FBI, I will do anything for them. If they want me to I will even be photographed with an agent and point out a Communist for them. Tell Mr. Hoover [FBI Director J. Edgar Hoover] I am on his side."
—JOHN WAYNE ON BLACKLISTING IN HOLLYWOOD

Billionaire producer Howard Hughes financially backed this film, and even funded the shipping of 60 tons of radioactive dirt to a Hollywood set for retakes for *The Conquerer*. Fueled by guilt, he later paid $12 million for every existing print of the film.

"If I had known this, I would've put that patch on 35 years ago."
—JOHN WAYNE ON RECEIVING AN OSCAR FOR *TRUE GRIT*

Wayne was offered the starring role in the Oscar-winning
The Dirty Dozen (1967) but opted instead to direct
his own *The Green Berets (1968).*

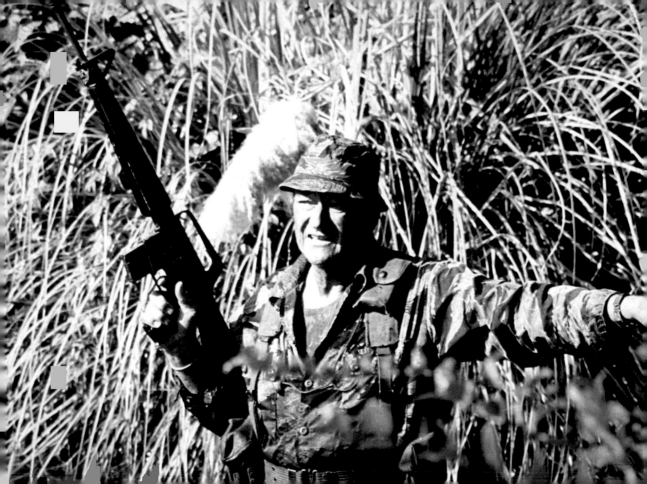

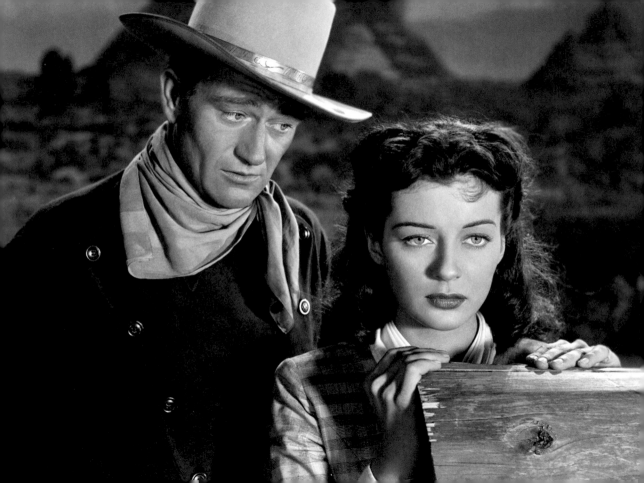

"If everything isn't black and white, I say, why the hell not?"
—JOHN WAYNE

Wayne accidentally shot close friend and *3 Godfathers* (1948) costar, Ward Bond, on a hunting trip. Bond willed the shotgun to him when he died on November 5, 1960.

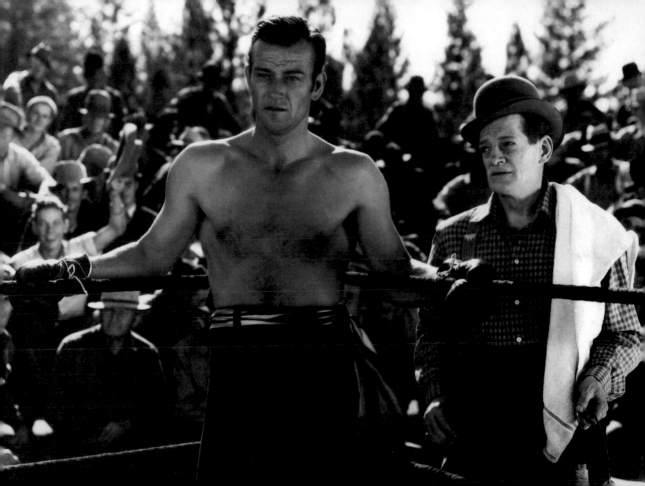

"I wrote to the head man at General Motors and said,
'I'm gonna have to desert you if
you don't stop making cars for women.'"
—John Wayne

There were claims that *McQ* (1974) and *Brannigan* were John Wayne's answers to Clint Eastwood's tough cop in *Dirty Harry*.

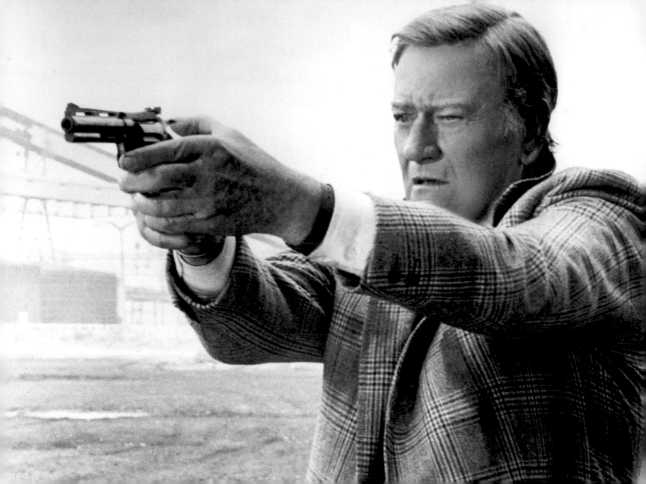

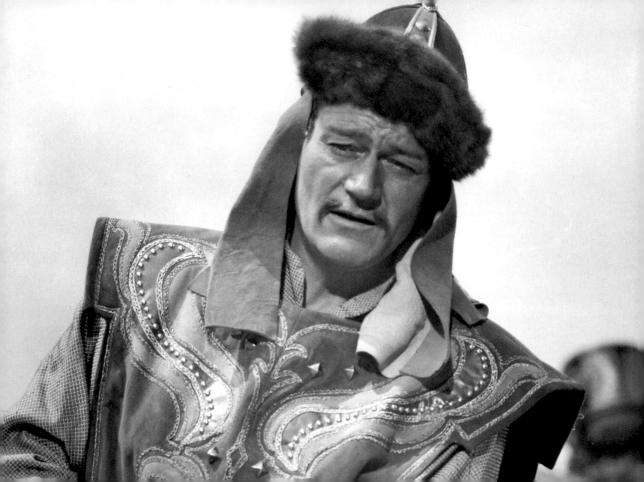

It's reported that a number of the crew members on the set of *The Conqueror* later developed cancer, allegedly due to producer Howard Hughes' decision to film in a Utah desert, not far from atomic testing grounds.

Feeling so strongly about *The Alamo*, Wayne remortgaged his home in Hollywood and sacrificed a great deal of his shares in the film's profits. The movie was a success, but he lost money from the financial arrangements.

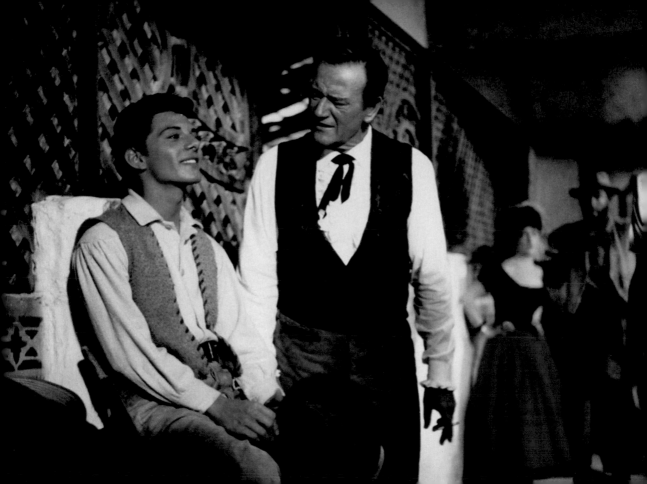

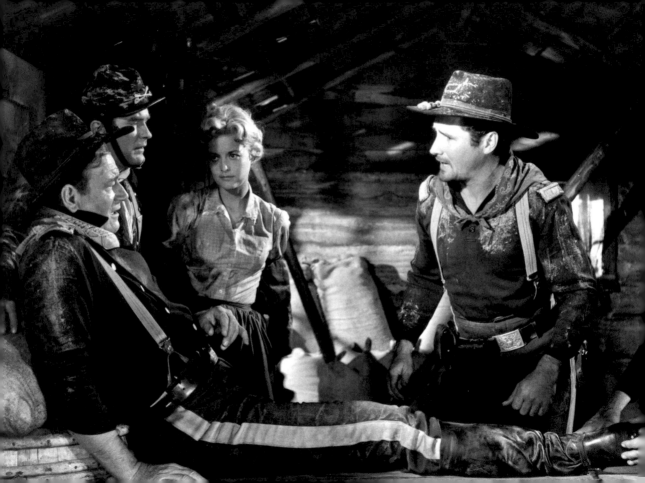

"What are they trying to do, bury me? Tell them to forget it.
I just got my second wind."
—JOHN WAYNE

Ironically, Wayne recorded an advertisement for Camel cigarettes on the set of *Big Jim McLain* (1952).

Wayne began suffering from lung cancer during the filming of *Circus World*, and the following years were difficult for him. Besides the removal of a cancerous lung in 1964, he also had a heart valve replacement in 1978, and his stomach removed the year after that.

"Don't ever for a minute make the mistake of looking down your nose at Westerns."
—JOHN WAYNE

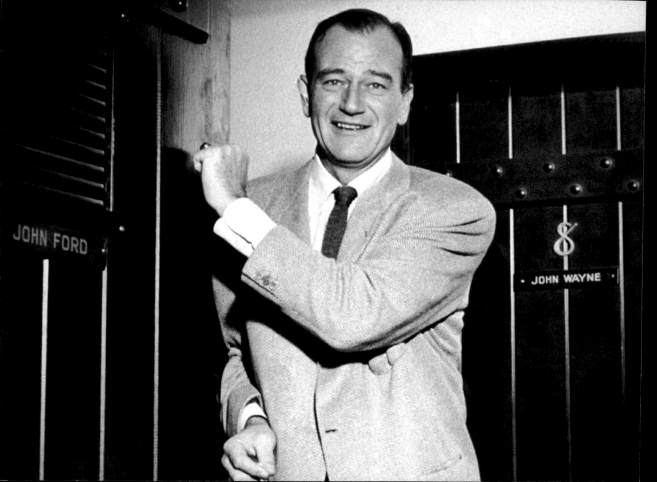

From *Wake of the Red Witch* (1948) onwards, Wayne's thinning hair caused him to wear a toupee.

"I'd like to know why well-educated
idiots keep apologizing for lazy and complaining people who
think the world owes them a living."
—JOHN WAYNE

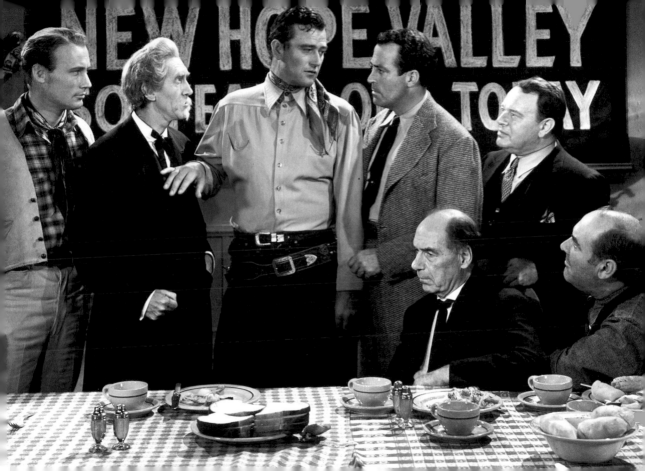

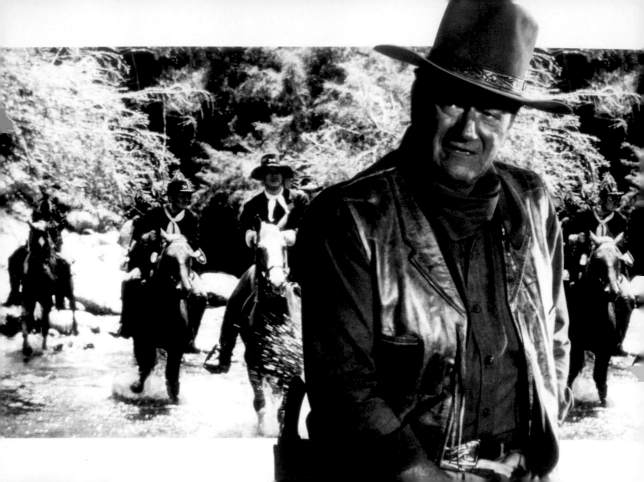

"What I wanted to say in the film was that American's need to be prepared to defend their freedom. That was the theme of many of my films, and it's no accident I chose those themes."
—JOHN WAYNE ON *ALLEGHENY UPRISING* (1939)

There's been much speculation as to why *The Man Who Shot Liberty Valance* was in black and white in a Technicolor age. Director John Ford made claims of the added tension it would provide; crewmembers reported budget issues and the need to cut costs.

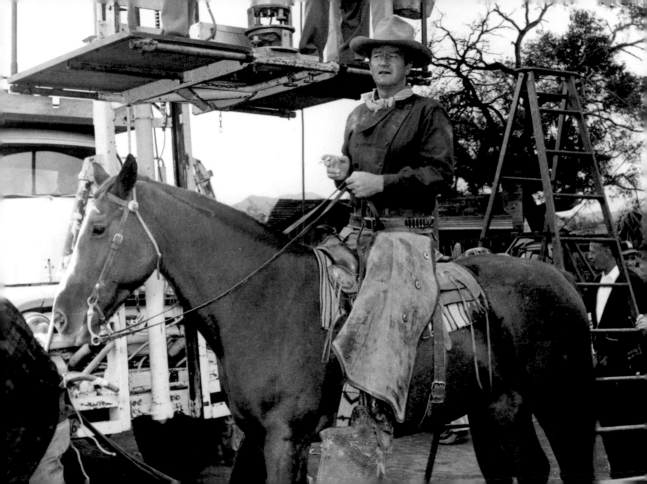

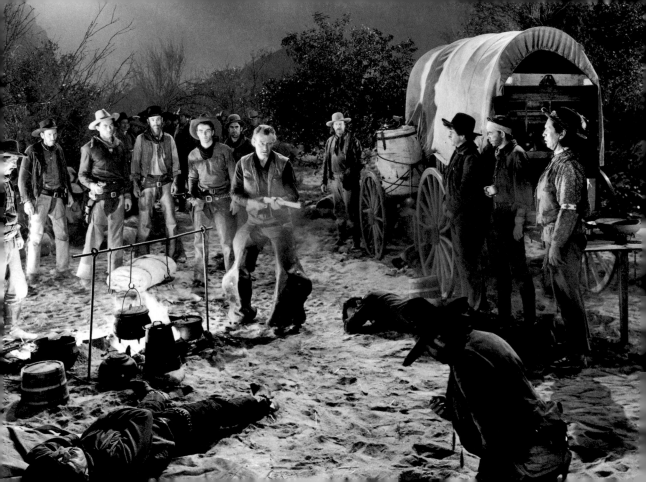

"Television has a tendency to reach a little. In their Westerns, they are getting away from the simplicity and the fact that those men were fighting the elements and the rawness of nature and didn't have time for this couch-work."

—John Wayne

Wayne appeared in a single episode in the fifth season of *I Love Lucy* that aired on October 10, 1955.

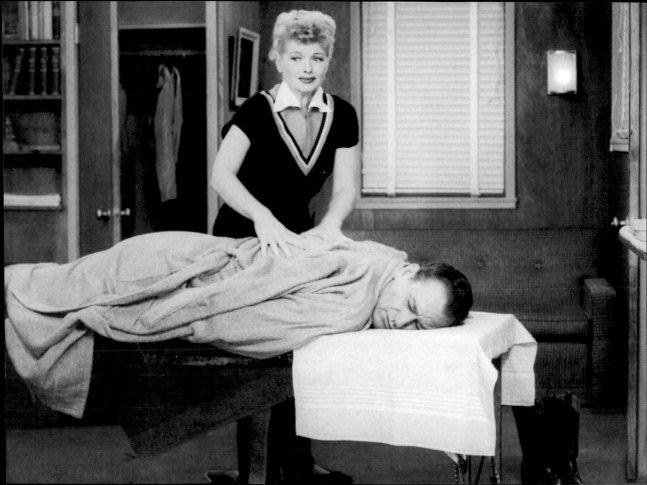

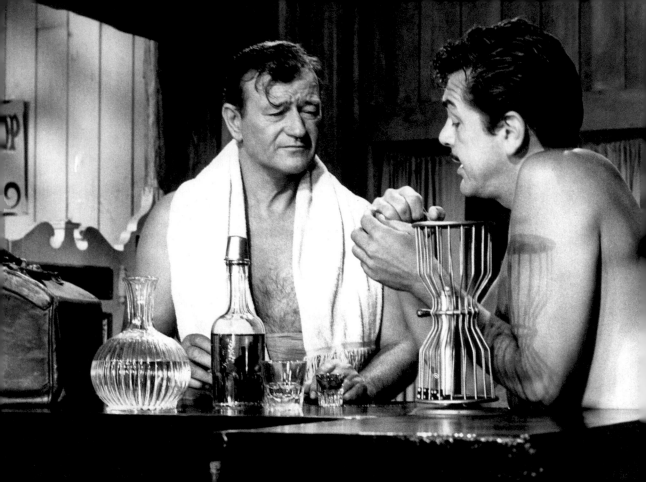

"I drink as much as I ever did. I eat more than
I should. And my sex life is none of
your goddamn business."
—WAYNE IN HIS FAMOUS *PLAYBOY* INTERVIEW

Fearing that Vietnam protesters would dishonor his gravesite, Wayne was laid to rest in secrecy and his plot remained unmarked. It wasn't until 1999, twenty years after his death that a headstone made of bronze was placed at the site in his remembrance.

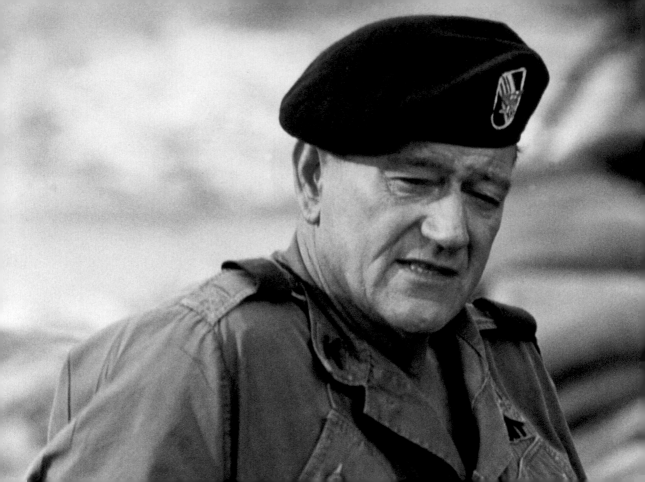

"They can't lay a glove on me with their mean-spirited words, because I've faced worse than them."
—JOHN WAYNE ON LIBERALS

Information from Soviet archives, reported in 2003, indicates that Joseph Stalin ordered Wayne's assassination, but died before the killing could be accomplished.

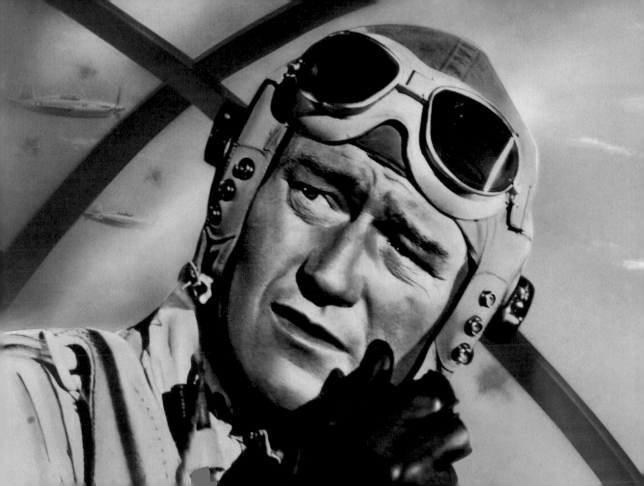

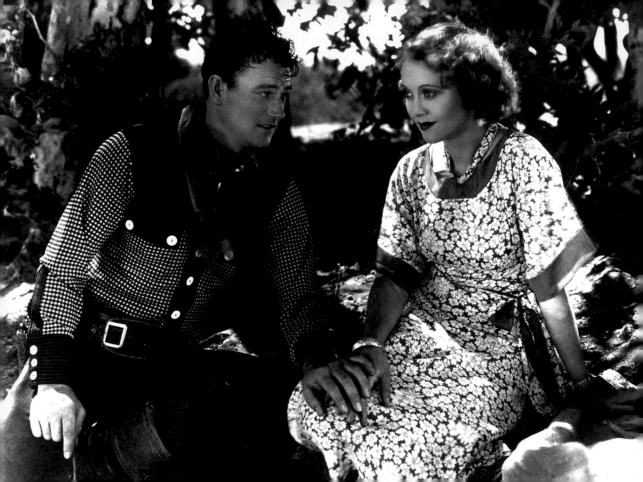

"Pushy dames really scare him. Duke's really old-fashioned about women; no off-color stories in their presence."
—JAMES GRANT, SCREENWRITER

During the 1960s, Wayne frequented Panama and purchased the island of Taborcillo just off its coast.

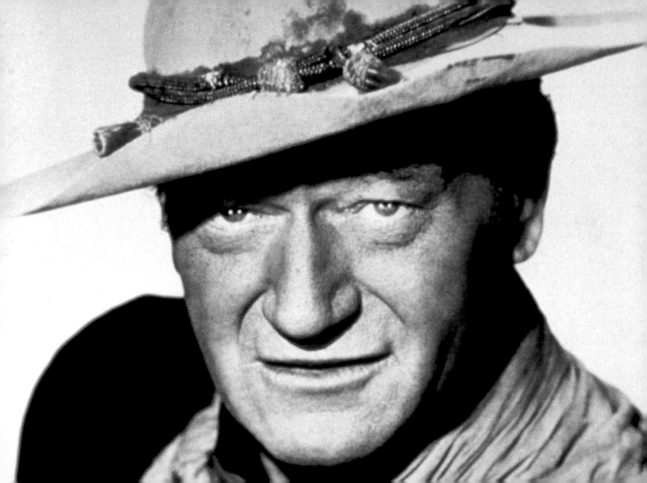

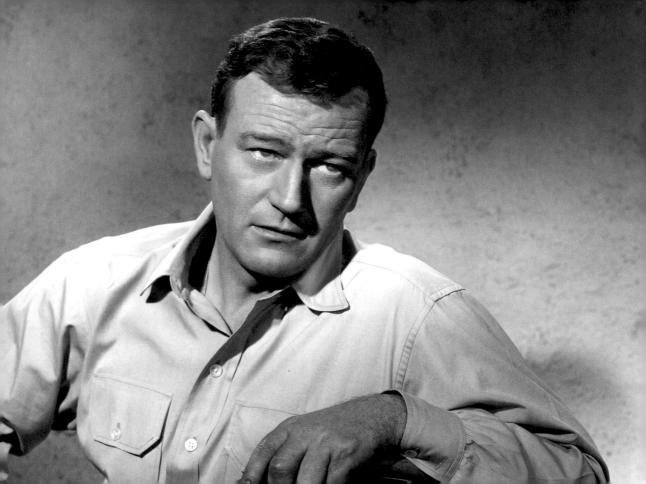

"I don't know if I love it or hate it, but there sure has never been any form of entertainment so . . . so . . . available to the human race with so little effort since they invented marital sex."
—JOHN WAYNE ON TELEVISION

Though shooting of *El Dorado* wrapped up in 1965, and the film was screened in 1966, it would not hit the box office until June 1967.

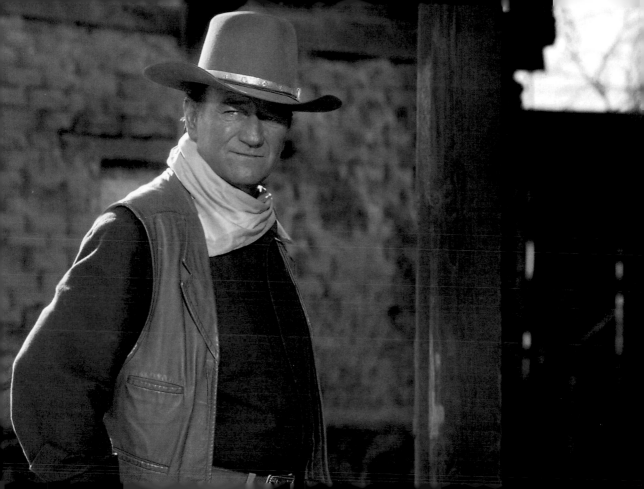

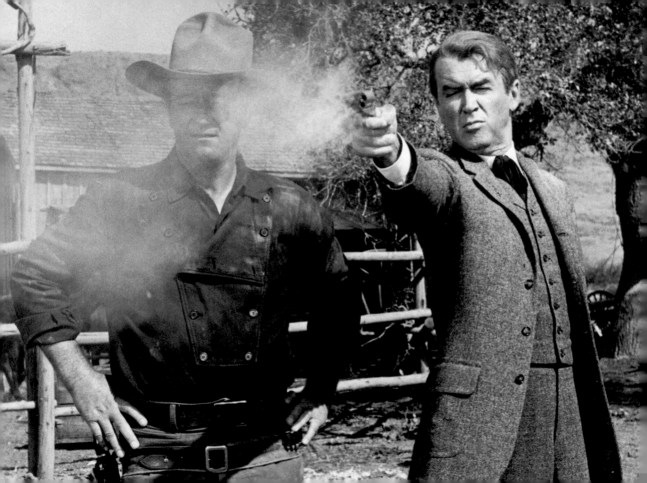

"Out here a man settles his own problems."
—JOHN WAYNE, IN *THE MAN
WHO SHOT LIBERTY VALANCE* (1962).

"Screw ambiguity. Perversion and corruption masquerade as ambiguity. I don't trust ambiguity."
—JOHN WAYNE

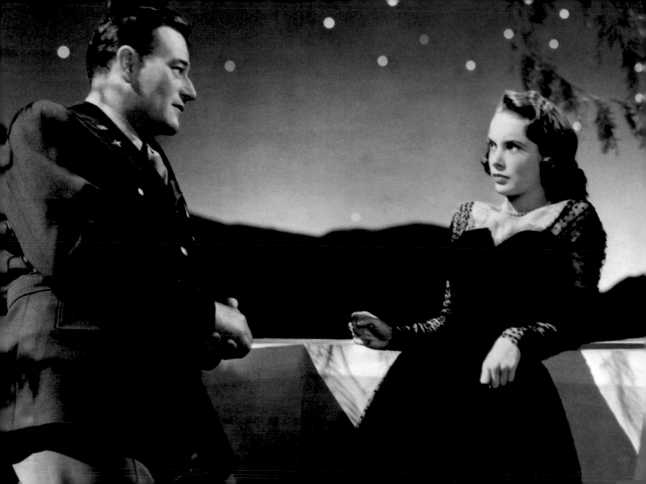

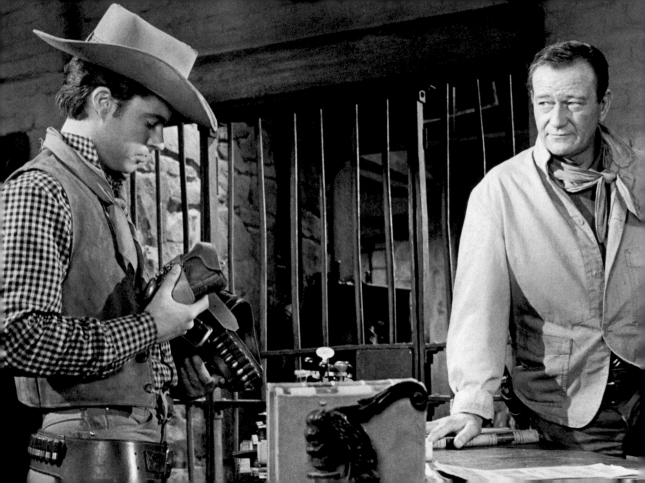

"Sorry don't get it done, Dude."
—JOHN WAYNE IN *RIO BRAVO* (1959)

"I don't think a fella should be able to sit on his backside and receive welfare."
—JOHN WAYNE

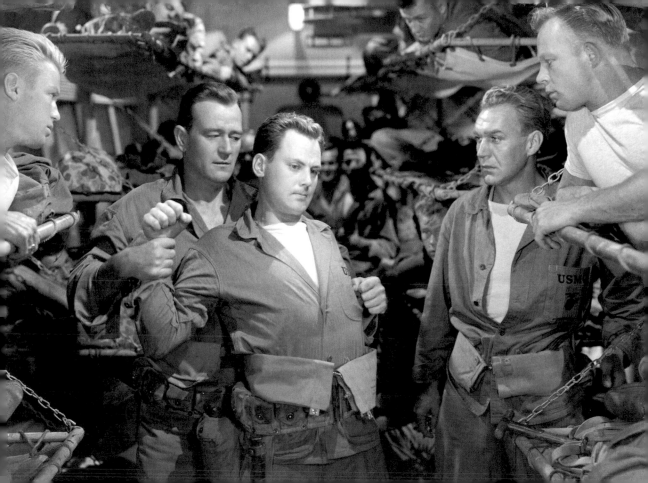

The Green Berets (1968) made $7 million in the first
three months of its release.

Wayne was so no-nonsense about his role as Genghis Khan in *The Conqueror*, he went on a strenuous diet and began taking Dexedrine tablets to stimulate weight loss.

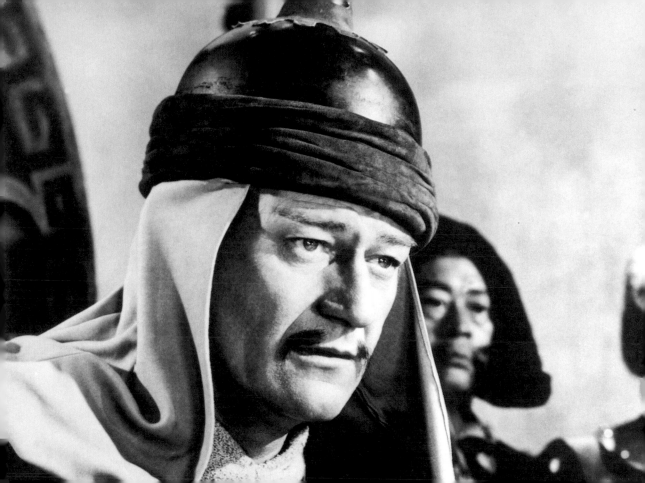

"I don't guess people's hearts got anything to do with a calendar."
—JOHN WAYNE IN *HONDO*

"I don't feel we did wrong in taking this great country away from them. There were great numbers of people who needed new land, and the Indians were selfishly trying to keep it for themselves."
—John Wayne

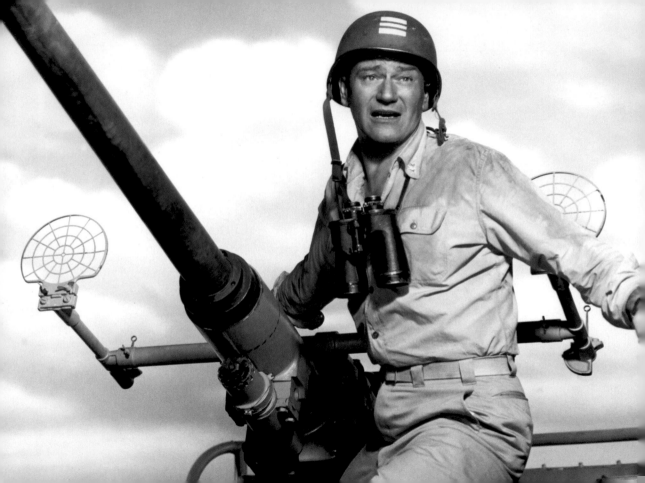

Because of his age (34), Wayne was eligible for exemption from serving in the U.S. Army. There were a slew of other actors enlisted, including many of his peers and colleagues. It's reported that Wayne constantly contemplated it, but shelved it constantly until "after he finished one more film."

"Put a man on a horse, and right off you've got the making of something magnificent. Physical strength, speed where you can feel it, plus heroism. And the hero, he's big and strong. You pit another strong man against him, with both their lives at stake, and right there's a simplicity of conflict you just can't beat."

—JOHN WAYNE

"Nobody should see this movie, unless he believes in heroes."
—JOHN WAYNE ON *THE ALAMO*

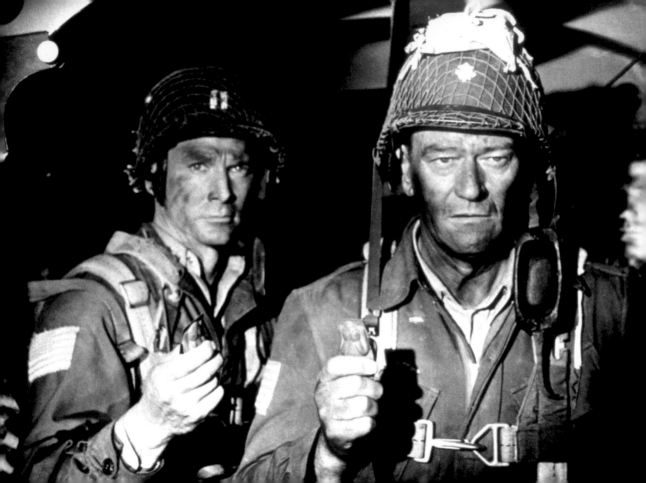

"I stick to simple themes. Love. Hate. No nuances. I stay away from psychoanalyst's couch scenes."
—JOHN WAYNE

"Now don't get any ideas. It would make me upset if I had
to put a bullet in your back."
—JOHN WAYNE IN *THE COMANCHEROS* (1961)

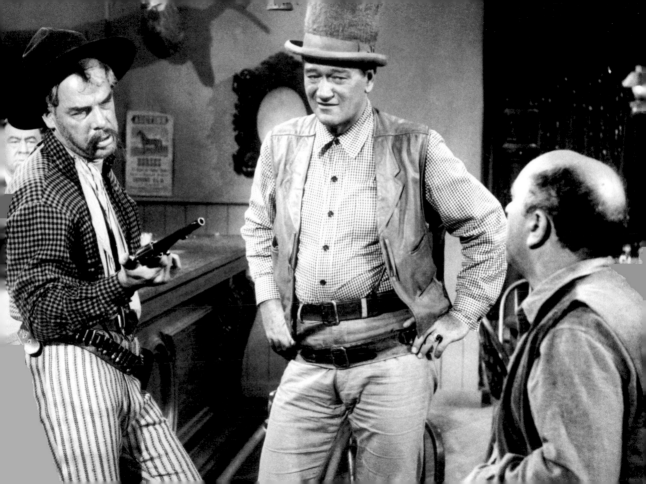

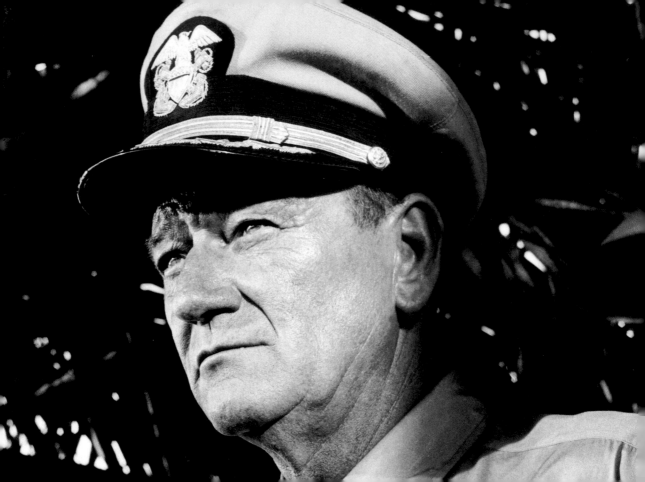

By the ending of *In Harm's Way*, Wayne's lung cancer was severe and he was coughing up blood.
His left lung and three ribs were removed no less than two months after shooting wrapped.

"I think government is a necessary evil, like,
say, motion picture agents."
—JOHN WAYNE

"The script really called for a younger guy. I felt awkward romancing a young girl at my age."
—JOHN WAYNE ON *DONOVAN'S REEF*

"I read someplace that I used to make B-pictures. Hell, they were a lot farther down the alphabet than that . . . but not as far down as R and X. I think any man who makes an X-rated picture ought to be made to take his own daughter to see it."
—JOHN WAYNE

"I've known Jane Fonda since she was a little girl. I've never agreed with a word she's said, but would give my life defending her right to say it."
—JOHN WAYNE, ON JANE FONDA, DAUGHTER OF CLOSE FRIEND HENRY FONDA

Wayne's character in *The Wings of Eagles* (1957) is based on the life of Frank "Spig" Wead. The film is a tribute to Wead, who was a friend of director John Ford.

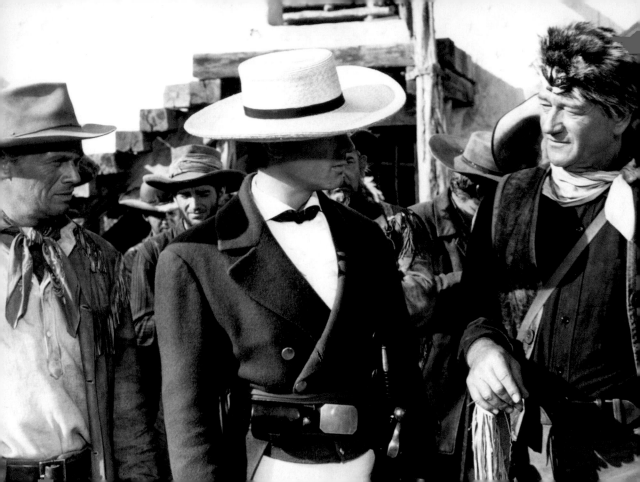

Wayne produced, directed, and starred in *The Alamo*, which he used as a vehicle to display his rightist attitude.

"I read dramatic lines undramatically and react to situations normally. This is not as simple as it sounds."
—JOHN WAYNE

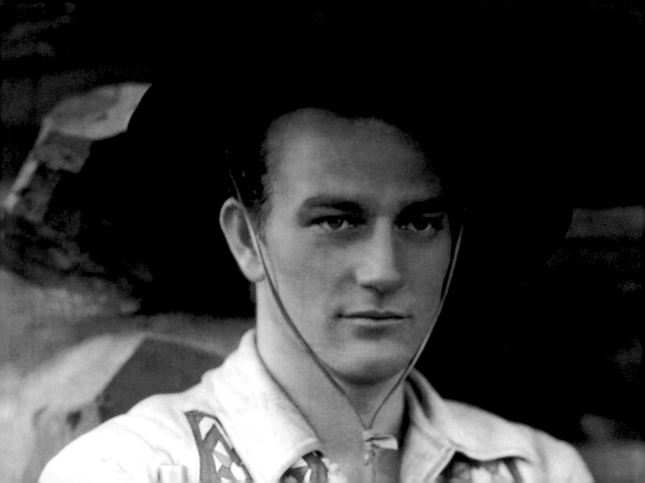

"All I do is sell sincerity, and I've been selling the hell out of that ever since I got started."
—JOHN WAYNE

On a tour of South America, a gift from producer Howard Hughes, Wayne was introduced to his third wife, Pilar Weldy, in Peru.

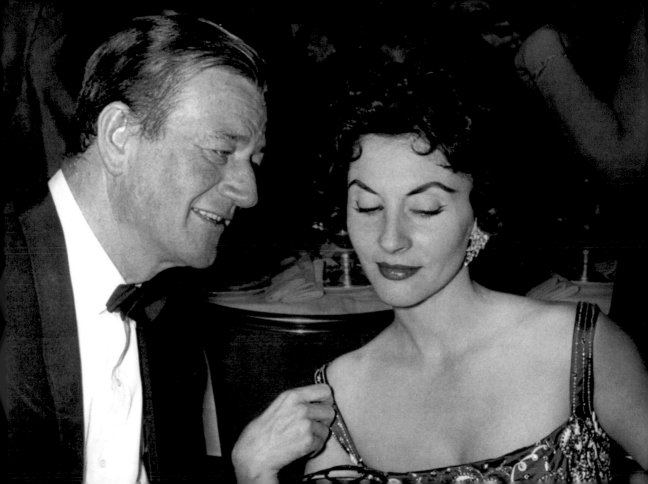

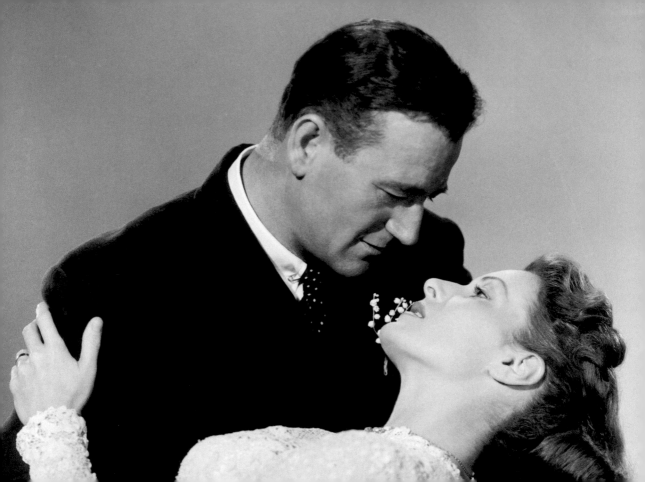

"I've had three wives, six children, and six grandchildren, and I still don't understand women."
—JOHN WAYNE

Wayne's marriage to his third wife, nicknamed Chata, was
explosive and unstable. She was certain he was
having an affair with sometimes costar Gail Russell and even
attempted to shoot him over the accusation.

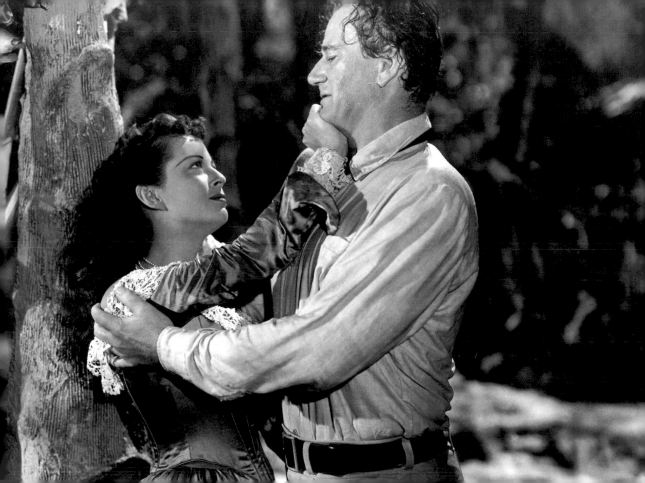

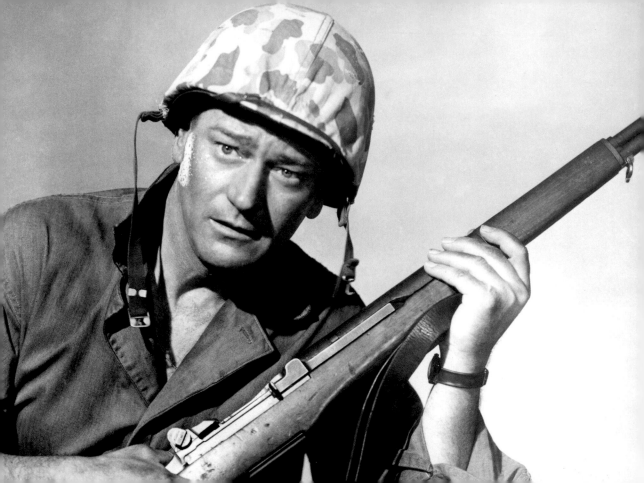

"All battles are fought by scared men who'd
rather be someplace else."
—JOHN WAYNE IN *IN HARM'S WAY*

No one expected Wayne's spoken word album *America: Why I Love Her* to become a hit and Grammy nominee. It was reissued on compact disc after the events of 9/11.

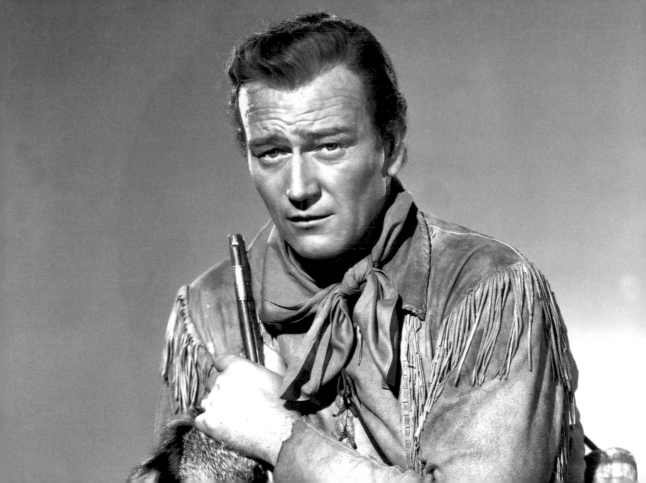

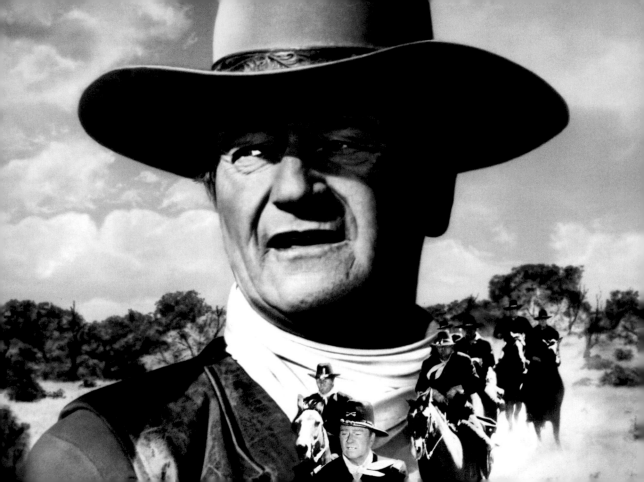

"Duke was never an actor. By that, I mean that he had to do everything real. There wasn't anything in Duke that would allow him to pretend to be something."
—Henry Hathaway

Wayne was so displeased with the final editing of *The Shootist*,
which ended the film with him shooting a man
in the back. "I've made over 250 pictures and have never shot
a guy in the back. Change it," he demanded.
The director eventually did.

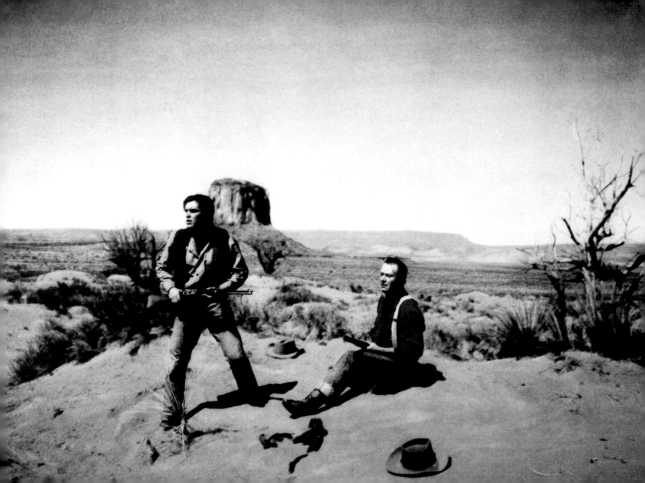

"I got to a point when I felt that I couldn't go on playing the tough gunfighter, and I was looking for something with a different angle to it. So when Warner Bros. sent me a script called *The Cowboys*, I saw that it was the kind of thing I was looking for."
—John Wayne

"I drink for comradeship, and when I drink for comradeship,
I don't bother to keep count."
—JOHN WAYNE

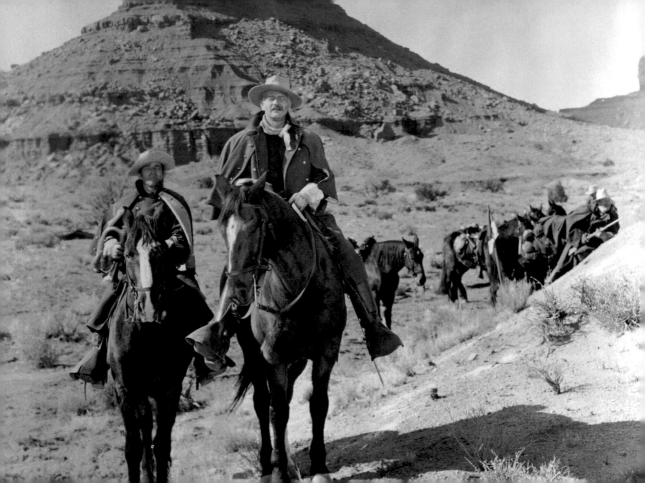

"What really impressed me about Duke was he could stay up late at night, playing cards—and losing every hand— and drinking, but he was still up early every morning, and knew not only all his lines, but everyone else's too."
—BEN JOHNSON, COSTAR IN *SHE WORE A YELLOW RIBBON* (1949)

Wayne had plastic surgery to remove the lines around his eyes in 1963.

498

Wayne's legendary status was far-reaching. When Emperor Hirohito, the 124th emperor of Japan, journeyed to the United States, he requested Wayne's company, even though Wayne had killed hundreds of Japanese warriors on film.

"He would become a 'super patriot' for the rest of his life trying to atone for staying home."
—Pilar Weldy, Wayne's third wife

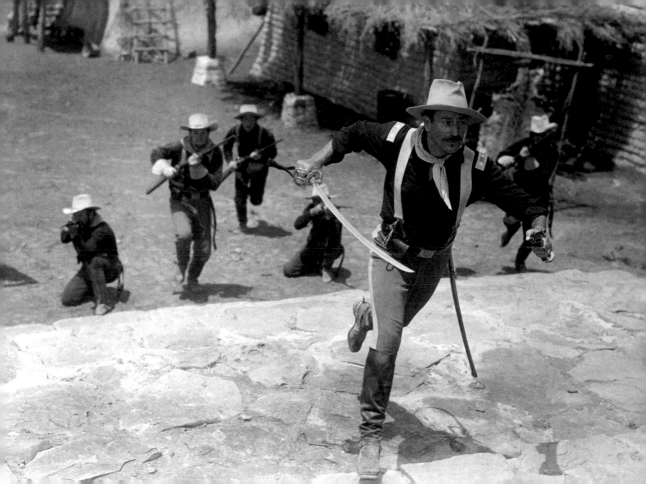

The John Wayne Cancer Society, founded in 1985, has a hand in helping "bring courage, strength and grit" to the fight against cancer.

"It's not phony. It's real hair. Of course, it's not mine, but it's real."
—JOHN WAYNE ON HIS HAIRPIECE

"How can I hate John Wayne upholding Goldwater and yet love him tenderly when he abruptly takes Natalie Wood into his arms in the last reel of The Searchers? . . . I was moved to tears in a darkened theatre in Paris."
—JEAN-LUC GODARD, FILMMAKER

During the shooting of *They Were Expendable*, John Ford reportedly insulted John Wayne regularly for his lack of service in the U.S. armed forces. Ford himself served proudly in the U.S. Navy and considered it cowardly that Wayne had not even enlisted.

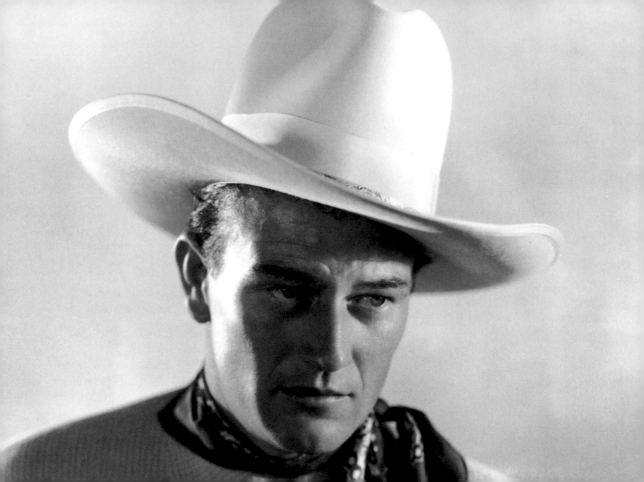

"His body spoke a highly specific language of 'manliness,' of self-reliant authority. It was a body impervious to outside forces, expressing a mind narrow but focused, fixed on the task, impatient with complexity. This is a dangerous ideal to foster. It is 'male' in a way that has rightly become suspect—one-sided, exclusive of values conventionally labeled female."
—GARY WILLS, AUTHOR

"He's not something out of a book, governed by acting rules."
—JOHN FORD

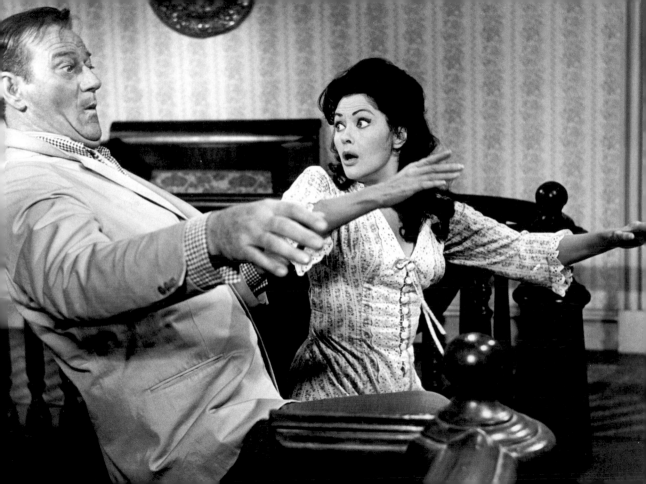

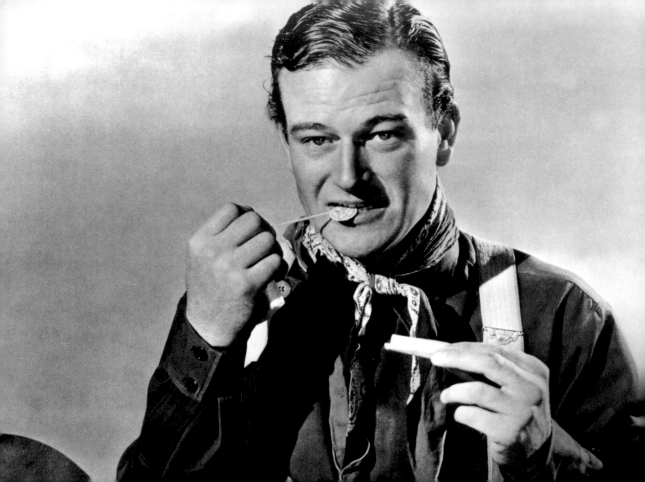

"Hell, I hope I'm never even nominated again. It's meat-and-potato roles for me from now on."
—JOHN WAYNE, AFTER FAILING TO WIN THE BEST
ACTOR OSCAR FOR *SANDS OF IWO JIMA*

As well as being the last film the Duke made, *The Shootist* is also one of the few films his character died in.

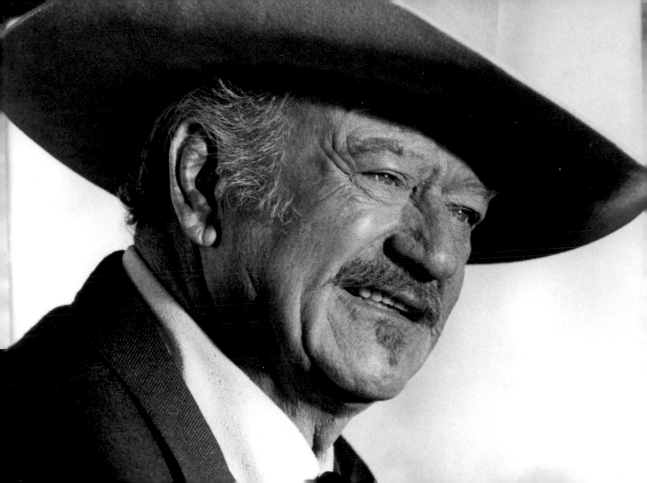

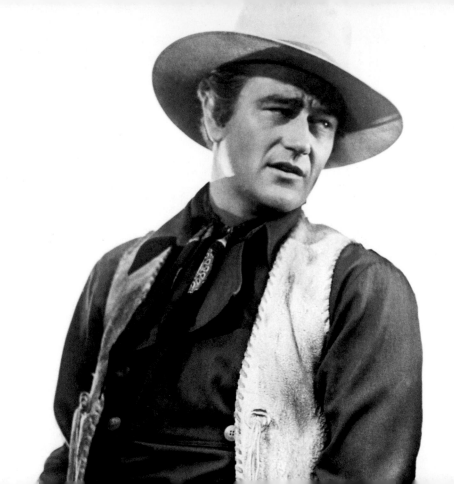

"He was honest, strong, independent, and proud. He's exactly the kind of man he portrayed in *The Shootist*. We didn't know it then, but John Wayne was telling us the rules he lived by, on screen and off."

—JAMES ARNESS

"He never cared for jewelry because 'it's so easy
to overdo and look flashy.'"
—Pilar Weldy, Wayne's third wife

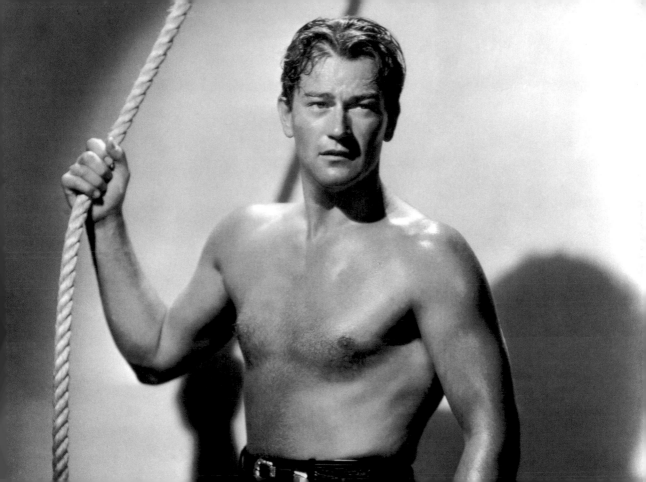

"Getting rid of a man without hurting his masculinity is a problem. 'Get out' and 'I never want to see you again' might sound like a challenge. If you want to get rid of a man, I suggest saying, 'I love you . . . I want to marry you . . . I want to have your children.' Sometimes they leave skid marks."
—JOHN WAYNE

In tribute to his impact, California Governor Arnold Schwarzenegger declared May 26, 2007, John Wayne Day in California. Schwarzenegger said, "John Wayne may have been a celluloid hero, but his heroic deeds in two dimensions inspired generations of real heroes in real life."

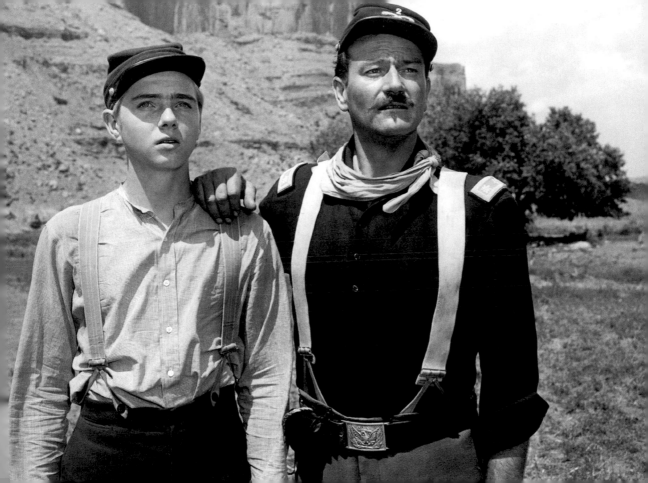

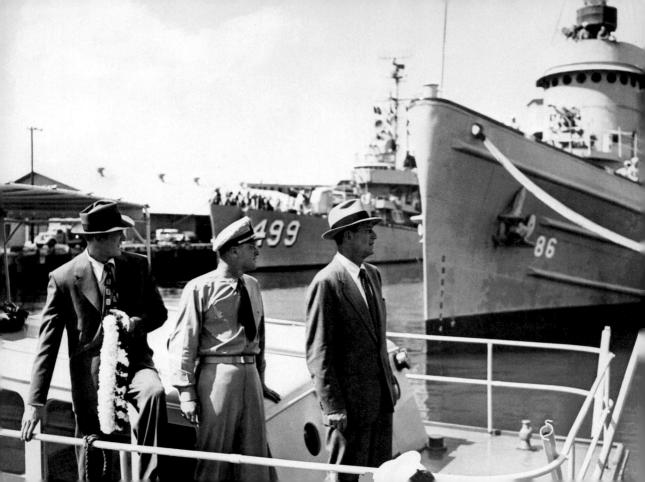

"Even J. Edgar Hoover had the film investigated. He sent agents to Hawaii to check us out. He thought we were playing FBI agents and he wanted to know how the FBI would come across."

—WAYNE SAID OF THIS ROLE IN *BIG JIM MCLAIN*

"Never think anyone is better than you, but never assume you're superior to anyone else."
—John Wayne

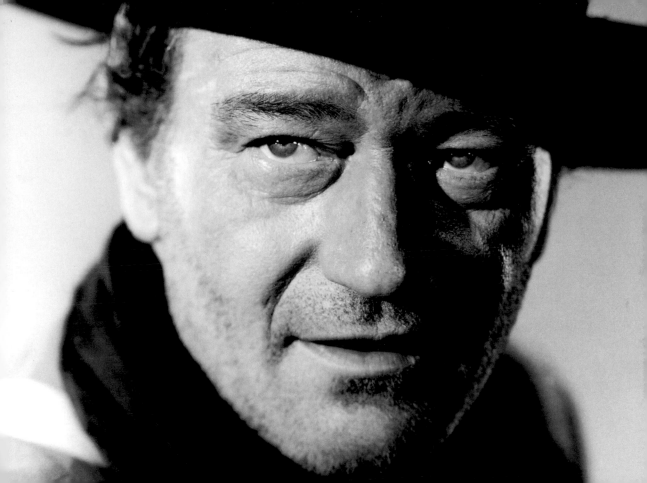

The day of his death, the flame of the Olympic Torch at the Coliseum in Los Angeles was lit in his memory.

"I play the kind of man I'd like to have been."
—JOHN WAYNE

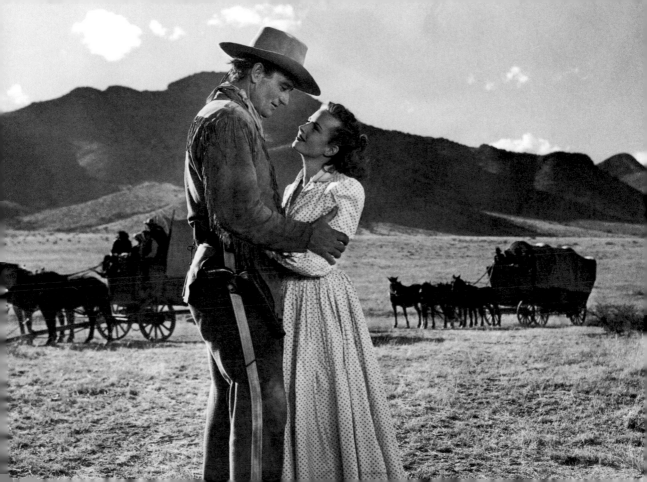

"Try and be decent to everyone, until they
give you reason not to."
—JOHN WAYNE

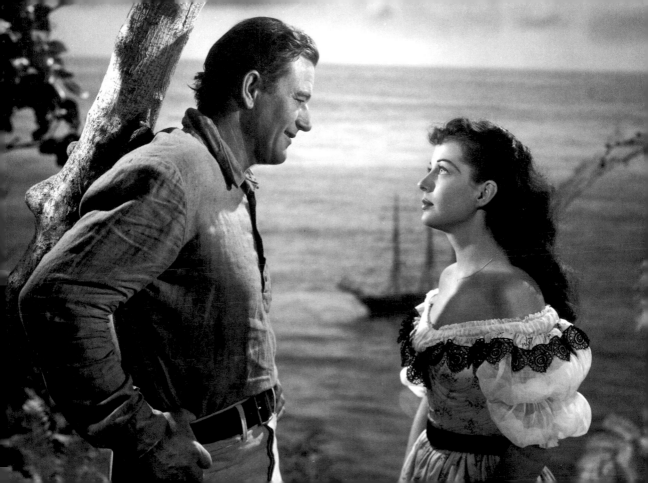

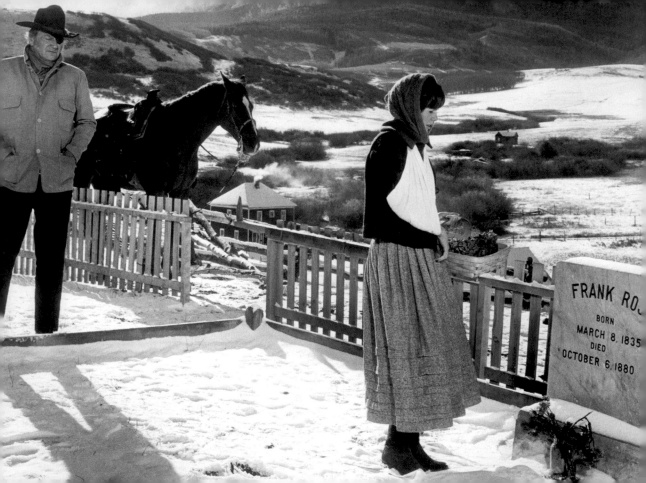

"God, how I hate solemn funerals. When I die, take me in a room and burn me. Then my family and a few good friends should get together, have a few good belts, and talk about the crazy old times we all had together."

—JOHN WAYNE

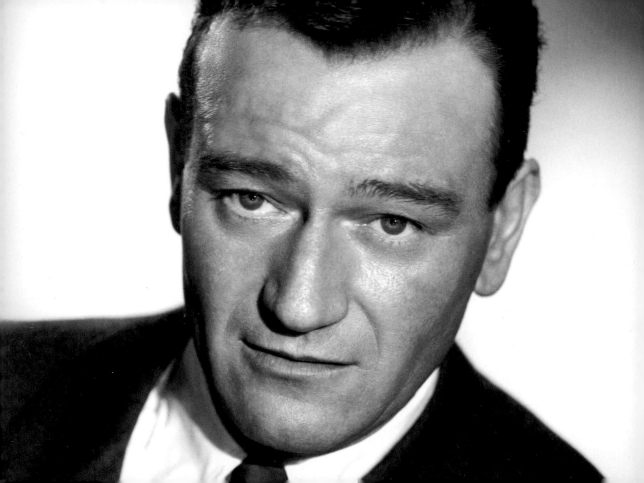

PHOTOGRAPHY CREDITS

Photofest (all images except as noted below)

Doctor Macro p. 12, 35, 26, 51, 92, 135 144, 156, 167, 176, 195, 196, 200, 227, 235, 243, 259, 271, 279, 295, 384, 404, 467, 468, 476, 512, 519, 527

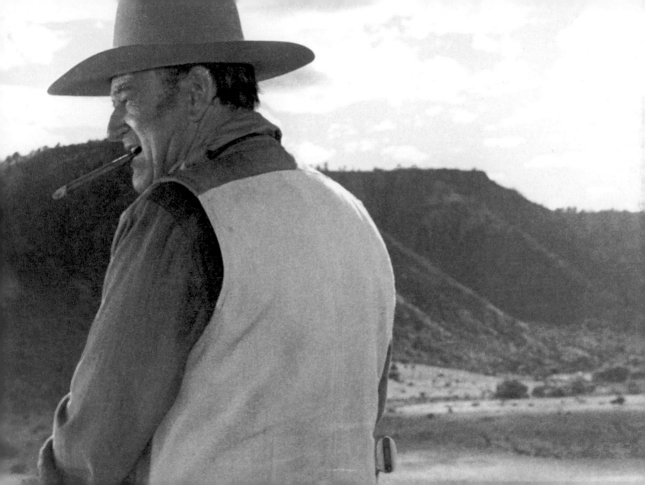